AE

D1231895

# AFRICAN 'PRIMITIVES':

## Function and Form in
## African Masks and Figures

# African 'Primitives':

## *Function and Form in African Masks and Figures*

G. W. SANNES

TRANSLATED BY
*Margaret King*

WITH PHOTOGRAPHS BY
*Marianne Dommisse*

FABER AND FABER
London

*First published in England in 1970*
*by Faber and Faber Limited*
*24 Russell Square London WC1*
*Printed in Great Britain by*
*Ebenezer Baylis and Son Limited*
*The Trinity Press, Worcester and London*

SBN 571 08836 8

Originally published in Holland by
N. V. De Tijdstroom, Lochem, under the title
*Afrikaanse Primitivien*:
*Functionele Schoonheid*
*van Maskers en Beelden*

# CONTENTS

Preface                                                     *page* 9

Function and form in African masks and figures                   11

Masks and figures                                                23

Sources of works illustrated                                    105

Bibliography                                                    107

Museums with collections of African art                         109

Index                                                           113

Map of Africa, showing tribes mentioned                          13

# PREFACE

OVER the years, a large number of books on Africa and its art, ranging from ethnological studies to picture books, of greater and lesser substance, have appeared in Holland and other countries.

Interest in African art has been stimulated by exhibitions and auctions and by the increase of ethnographic information in the press, on the radio and on television. Several art galleries have felt that their collections should include African sculpture and masks, and in recent times many Africans have left their country laden with trunks and boxes full of 'African art' in order to market their treasures in Europe and elsewhere, sometimes at exorbitant prices quite out of proportion to the value of the articles concerned. Ethnographic art is also collected by sculptors and designers, and not just for fashionable reasons but because they are seriously interested in its shapes and forms.

Even outstanding artists and modern art-collectors, however, sometimes show a remarkable blind spot about ethnographic art. Not infrequently they exhibit pieces of mediocre or thoroughly bad workmanship and artistry—for which they may have paid large sums. And if people with good qualifications can be incapable of showing discernment, and sometimes lavish attention on poor work, how are the uninitiated to pick their way through the African jungle?

It is for such reasons that an attempt has been made here to offer the reader a straightforward account of the function and aesthetic qualities of African carvings and masks by means of a short introduction followed by descriptions of a number of reproductions. These have been chosen to show reputable examples of the various forms rather than to illustrate the highest achievements in African art, and the descriptions assess their merit as well as describing their origins and purpose.

Finally, for those who want to know more about this art, there is a list of European and American museums, and a list of well-illustrated books, at the end. The latter is by no means complete but it may serve as a guide for those who wish to proceed further in the field.

# FUNCTION AND FORM IN
# AFRICAN MASKS AND FIGURES

'PRIMITIVE art' is a term that has for some time been applied to ornaments and utensils of the so-called 'primitive' peoples. It is an unsatisfactory one, with its implications of crudity of design and execution, and 'primary art' would be better; but the word 'primitive' has gained such currency that it must now be used, though it should only be accepted with some reserve.

The Westerner is very critical of craftsmanship and tends to see anything that falls short of Western standards of finish as clumsy, unfinished and rough-hewn. While it is perfectly true that these peoples can rightly be called technically underdeveloped, technical skills are not the be-all and end-all of man's life on earth, and Western man is apt to forget this.

There is, moreover, a tendency in all of us to raise our eyebrows at the customs, ideas and peculiarities of foreigners. It says something for our widening view of life that the tendency is on the wane. Indeed, it is fortunate that as nations and individuals we do have our own characters—it would be a dull and colourless prospect if this were not so. But even in a world made smaller by communications media, there is a remarkable lack of understanding between different peoples. This is not so much due to problems of language and meaning as to differences in the attitudes and modes of thought behind languages. It is these that make mutual understanding and appreciation extremely difficult.

Obviously these differences show not just in a nation's crafts but in its whole realm of ideas and whatever expresses them. Religious disputes and wars are, and always have been, based on man's conviction that his beliefs are the right ones, except of course where religion is merely used as a cloak for material ambition. Any one of the great religions will have many different streams, and representatives of these will be convinced that they are right and others wrong. It is true that we are occasionally told that all the streams must rise from a common source somewhere, and that they could perhaps unite in one great channel; but the achievement of this ideal is not easy so long as each stream considers itself the mainstream.

The religion of many primitive peoples is distinct from the well-known religions like

Islam, Buddhism and Christianity in that it generally recognizes numerous lower gods or spirits in addition to the single so-called creator-god. This creator-god is not normally portrayed, but the lower beings, and especially the ancestors of the human race, are popular themes. Moreover, their belief is that anything may have a spirit: not just man, but animals, vegetation and even lifeless matter can share the same divine life-force. This is known as animism. Clearly, these spirits can have either a good or a harmful influence, and people are anxious to attract the good influences and find ways of fending off the evil ones. They are always part of that world and are very much aware of it. To us in the West it may seem a fearful and oppressive condition, but it is doubtful whether primitive people experience it as such. Just as we avoid walking under ladders, or throw a pinch of salt over our shoulder when we have spilt some, or 'touch wood', so they have their means of warding off danger. And this certainly does not necessarily imply black magic, exorcizing rites and incantations. Black magic, which generally has evil intentions, is reprehensible in the eyes of Africans, too, and they fear and shun those who practise it. To Europeans, however, African magic implies witchcraft—a black art. For a clearer understanding of what is really involved we have Father Tempels' description of 'witchcraft' in his book called *Bantu Philosophy*: 'What we call witchcraft, is to the Bantu negro merely the application of natural forces which God has put at man's disposal for increasing his vitality.'

This vital principle is at the centre of negro thinking. For him it is of the utmost importance to retain his vital power and if possible to strengthen it, and 'magic' procedures are one means towards this end. These procedures—conducted by the witchdoctor, the guardian and possessor of the tribal secrets—are also designed to restore order out of chaos in the negro's own circle and in his village. Some carvings are used, like other magical objects, as a kind of intermediary in the process. Such animistic thinking is closely associated with the cult of the spirits of the dead in which the ancestral image plays an important part. The ancestral image serves to link past and present, to provide a repository for the ancestor's spirit, and to transfer its life-force to the possessor of the image. Thus the dead person lives on in the image, and the image is often considered to be alive. This concept of man being subject to God, to supernatural forces and to his ancestors is essentially a religious one.

Animism is a potent factor in the self-expression of primitive peoples and especially of Africans and those of African origin. And it is these African peoples and the forms in which they express their spiritual needs that are, I hope, clearly and faithfully represented in the illustrations and descriptions that follow.

Before going on to look at the African art forms themselves, we should note that it is precisely the 'illiterates' who, by expressing their spiritual life in sculpture, have sometimes achieved the highest forms. An American book on negro art has the title of *African sculpture speaks*, and rightly so. As well as the mask, which only really comes into its own

Mediterranean Sea

Sahara Desert

R. Senegal

R. Niger

R. Nile

Red Sea

2 3
4
5 6

1

7 8 9

10

R. Congo

Atlantic
Ocean

Lake
Victoria

11

12

13

Indian
Ocean

Kalahari
Desert

1 Baga
2 Bambara
3 Dogon
4 Bobo
5 Senufo
6 Lobi
7 Dan
8 Guro
9 Baule
10 Bini
11 Bakuba
12 Bayaka
13 Baluba

when it is in motion, the negro also has the dance to help him retain his life-force. This is typified in the title of another book called *Les Hommes de la Danse*. Both titles convey in a nutshell essential characteristics of African life.

It is a remarkable fact that not all African tribes—and there are a great many of them—have produced carvings of any note. Broadly speaking, the tribes that have produced them are found in the area encompassed by the Sahara, the Great Lakes, the Kalahari and the Atlantic Ocean. This is not the place to attempt a detailed explanation of such a complex phenomenon. The basic fact is that most of the plastic art is produced by farming tribes, and that nothing of merit is produced by hunting tribes who lead a nomadic life. The explanation usually given is that nomads tend to travel light. It cannot be verified and even if it could be, we might have expected smaller-sized sculptures rather than none at all. However, these are the facts; added to which is the circumstance that the farming tribes, with their fixed areas of residence, frequently have a social structure that is matrilineal, whereas the community in the nomadic hunting tribes is more often based on a patrilineal system.

Finally, it should be borne in mind that for hundreds or even thousands of years Africa has been an arena for infiltration by foreign peoples and cultures. We can clearly trace Mediterranean influences (e.g. in the similarity between the famous cave-murals of Spain and those of the Sahara, and the well-known bronze sculptures of the Bini tribe in the Niger delta) as well as influences from a more easterly direction. These tribal migrations usually moved from north to south, and from north-east to south-west. What is so remarkable here is that the negro assimilated all these influences into a philosophy entirely his own. He rejected the things that were alien to his nature, and adopted or adapted whatever was consistent with his view of life.

In speaking of art forms in this context we have to modify the normal meaning of the term as used in the West. For whereas in the Western world works of art are often created for their own sake (*l'art pour l'art*), the situation in Africa is quite different. To the negro, art is the visual representation of the invisible and transcendental. Almost without exception, masks, images, and even utensils perform some religious and generally ritualistic function.

It is often thought that African images are idols. Nothing could be further from the truth. As we have seen, most of them are ancestral images, and this is understandable since the negro accredits his forebears with extraordinary powers which he would gladly add to his own life-force. He makes an image of his ancestor—or has one made—into which the dead person's powers can pass, and this image is placed on his household altar where it is surrounded with reverence. When important questions arise, the image may be consulted and offerings made. When a member of the family is dying, the image may be placed by his side so that the departing spirit can come to rest in it and strengthen it. So the older the image, the greater its power.

Not all images are ancestral. There are some portrait-images, though they are uncommon. Those of the Baule tribe on the Ivory Coast are well known, and the connoisseur can recognize them not only by their features but by their individual tattoo marks. They would be made, for instance, as a reminder of someone who had gone away or died, just as we have photographs made. Portrait-images were also made of princes or chiefs as a mark of respect. The portrait-images of the Bini (Nigeria) and the Bakuba (Congo) are familiar examples of this kind, although here it is more a question of the portrayal of the office than the office-bearer.

Then there are the images known as fetishes. Although many other African figures are frequently classed in this category, they are, in fact, a distinct group. The purpose of the fetish is to gain power over something or someone, to ward off or bring on disease or disaster, to make predictions and such like. The fetish belongs to the ritual of offerings, and when the aim is to inflict evil, it has overtones of 'black magic'. The nail effigies, for instance, that are found almost exclusively among the Bakongo (Congo), have such intentions. We may recall that even to this day, nail effigies are not unknown in Holland and Belgium, and the fact that their existence in Africa has remained virtually confined to the Bakongo group can in all probability be ascribed to European (Portuguese) influences since the sixteenth century. Among the fetishes we ought strictly to include those objects whose sole function is to promote childbearing, too—fertility images, *maternités* and the like.

African masks are no less important than the images, but their function is essentially different. They are meant for protection and, like initiation rites, they are generally connected with the cult of the dead. During initiation rites, the person to be initiated symbolically leaves his former (youthful) life so as to be reborn into an adult person who is mature enough to be admitted into the tribe. Initiation-masks are often gruesome, for the candidate has to prove his courage. They may also be displayed at the beginning and end of farming activities and of the rainy season, and as a reminder of important events in the people's history and mythology. One purpose of animal masks is to prevent the soul of a slaughtered animal from inflicting injury on the hunter or the tribe. Although the masks are nearly always associated with the dead, the same masks are also often used at fertility rites. Living and dying are closely connected, and the expression 'no life without death' is particularly applicable to the African negro.

Masks ought always to be looked at in motion. They are generally worn by a member of one of the many male secret societies, or one of the rarer female ones, and the masked person is completely hidden under a raffia or cotton garment so that the human associations of the mask are reduced to a minimum. The spectators must not know who the mask-bearer is. Should his (or her) identity be discovered, his life would be in danger. The moving mask becomes an independent being and the wearer of the mask also changes. He is no longer the same person as he was before the 'masquerade', since, as it progresses,

he completely identifies himself with whatever it is the mask is meant to portray—not to the extent of considering himself to be the other being, but he is conscious of being its personification. All this ensures that a masquerade, quite unlike a carnival pageant, can be entirely lifelike, convincing and often horrific. So convincing indeed that at male rites it could literally be the death of a woman or child, anyone uninitiated in fact, who caught an accidental glimpse of the forbidden mask.

Some of the masks are only used once and then destroyed. Others are used again and again, and in their long service, entailing repeated 'smoking', repainting and sacrificial sprinkling, acquire a fine and venerable patina. Masks like these are usually kept in sacred huts entered only by the high dignitaries of the society. As a result of the many libations poured onto them, they are liable to become so toxic that the wearers can be overcome by them. In which case they have outlasted their service and new ones will have to be made.

In some tribes, the making of masks and ancestor figures may be entrusted to any of their members; in others the task may only be allotted to one, or several, craftsmen, priests or medicine-men. The makers generally form a separate caste in which some form of family tradition is upheld. The medicine-man—who should not be confused with the practitioner of black magic—is held in high esteem among the people; he is their confidant, counsellor and doctor. The blacksmiths' or craftsmen's caste, on the other hand, is generally feared by the other members of a tribe and avoided as much as possible. It is understandable, since they are thought to be in communication with the cosmos and to be familiar with the heaven-sent fire with which they have dealings every day. The blacksmith is a kind of magician who, with the help of fire and ore, makes metal objects, while the medicine-man has power over life and death. The masks fashioned by these blacksmiths and medicine-men are made in the greatest secrecy. Aware of the high, religious purpose of his labour, the artist must carry out his work with the greatest concentration. It is in complete seclusion from the rest of the tribe, therefore, that a suitable tree in a sacred wood is usually selected and felled; and since trees, too, are thought to be animate, all this is preceded by offerings. The maker of the mask or image will work according to a traditional pattern which has remained almost unchanged for generations. Some images and masks which were brought in to museums as curios more than a century ago are exactly similar to those being produced today.

For someone familiar with African culture it is fairly easy to tell from an image or mask which territory, or even which tribe, it belongs to. But there are sometimes surprising departures from the expected pattern, perhaps as a result of influences from neighbouring tribes or a particular artist's originality. Sometimes a completely new design can be attributed to the institution of new rites or new secret societies. It is generally possible in the end, though, to ascribe these new objects, if only by 'feel', for every tribe has its characteristics, its particular atmosphere, which the expert can sense. And we should

remember that their territories cover areas many times as large as most European countries, and that a tribe can be divided into a number of sub-tribes, each one of which has its own deviations from the basic patterns of images and masks associated with the main tribe.

When an image or mask has only just been finished, it is not yet of any value to the maker or the tribe. It acquires its value through being hallowed by offerings, and the more it has been used and the more it has answered people's expectations, the greater its value will be.

Among the Dogon, a tribe found at the bend of the Niger, any member may be appointed to make a figure or mask. Obviously not every Dogon can be expected to be an artist and for that reason one would normally expect Dogon images and masks to be of average quality. Of course there are some very unskilled attempts among the work of competent artists, and even first-rate ones, but the overall standard is improved by people's familiarity with the carver's art from an early age. And if a tribesman is not very good at carving himself, he can always have his image or mask made for him by someone more skilled in the art—which will often be the expert, the blacksmith, priest or medicine-man.

An interesting fact is that many African carvings are tinted, though they are rarely painted. Elaborate painting of these objects is confined to a few tribes. Generally they are given a patina by the various treatments they undergo; a black mud bath, rubbing with the powdered red wood of the tukula tree, libations of milk, cream-beer, blood, chewed kola-nuts and so on.

Figures and masks are never very robust, though much depends on the kind of wood used. Soft wood is usually used for masks, mainly because they must be worn and soft wood weighs less, while either hard or soft woods are used for figures. Ebony, so popular among Europeans, is never used except for carvings intended for tourists and not for tribal use. Stone, bronze, brass and iron occur only very rarely in masks and images. Furthermore, the durability of the objects depends on the substances rubbed into them (for instance, oil, butter, mud), and whether they are used indoors or out of doors and whether they are exposed to the attacks of termites and to other hazards. In Africa any carving exposed to the elements would become 'old' in no time. A Belgian professor who had watched figures being carved in a certain place, saw them again three years later in the same spot and said he could have sworn, if he had not known better, that they were at least a hundred years old. Needless to say, an African carving made forty years ago is considered very old indeed by experts and collectors. Such carvings, and certainly any of an even greater age, have usually been preserved only because they have come into European collections after short service in Africa, or because they have been kept in extremely favourable conditions of humidity and heat in the African continent itself. A very few have been kept in this way for hundreds of years, but they are rare exceptions.

Before the turn of the century, Europeans viewed African art with a mildly benevolent

indulgence. It was, after all, so totally different from the art forms that suited Western tastes. In museums the African exhibits were at best relegated to the section of curiosities, and they were not regarded as art. People were accustomed to classical or neo-classical art which, in the main, depicts reality, even though it is often romantically expressed. But the beginning of the century saw many changes. Van Gogh's paintings had caused a stir, although there were still not many who looked on his work as art. Gauguin had left Europe to escape from its prevailing cultural ideas, and journeyed to the South Sea islands to study primitive people and their environment. Picasso was experimenting with all manner of techniques and styles. In German museums, Kirchner and Kisling—and others—were discovering the entirely different nature of negro art and seeing in it great possibilities for revitalizing the anaemic art of Europe. In Paris, the meeting-place of avant-garde painters, the recognition of the artistic expression in primitive sculpture sparked off great interest among artists. Small, individual collections were started by Matisse, Vlaminck, Derain, Picasso and others; and subsequent trends like cubism and more recent experimental art have shown the traces of its influence. Indeed, negro art, or rather the whole concept of 'primitive' art, has undoubtedly penetrated Western art to such a depth that it can be regarded as the progenitor of many current trends.

Modern experimentation must show a departure from the prototypes since, as we have seen, the negro carvings themselves have not been subject to much experimentation. The African carver has experimented only within the narrow confines of the ancient ritual pattern of his tribe. Herein lies his strength as well as his weakness: his strength being that of the complete dedication with which he portrays the African spirit, and his weakness the weakness inherent in design that derives from excessive repetition of a standard pattern. If this persistent danger is to be overcome, the individual artistry of the maker is obviously of the greatest importance. Not every negro is an artist, nor is every negro carving a work of art, but African plastic art is and remains, as it were, the spokesman for the people of Africa. The dance and the mask, which should normally be seen together, the ancestor figure and, to a lesser degree, the fetish, are for the negro what writing is for us. And finally we should remind ourselves that African carvings are rarely if ever intended to be appreciated as works of art.

Apart from its vitality—its life-force—African iconography derives its power from its harmonious quality: that is, its sense of balance between the component features of a sculpture, in the accentuation of what is important and the disregard of what is insignificant. African ancestral images always impart a great feeling of tranquillity; they have an inner conviction which commands respect. This quality is shared by many masks too, but in some of them the artist has allowed his fantasy full rein, and then gaiety or horror predominates. Others again are complete abstractions. But however unrealistic their shapes and proportions may be, this art form has the authenticity of an entirely acceptable reality for the Western observer with a receptive mind and a sensitive eye.

Nevertheless, we should be cautious in our interpretation of figures and masks. A seemingly melancholy figure may be meant to be cheerful or even grotesque, while a mask that strikes us as gay or peaceful may well be meant to convey something that is not either gay or peaceful.

Misconceptions about primitive art are generally based on false assumptions. In approaching it, we must recognize that because the negro's environment is so totally different from ours, the representation of his thought must be observed with eyes that have been freed from Western preconceptions. With the advent of modern photography, we no longer expect sculpture and painting to be 'picturesque' and 'true-to-life'; no more should we assume that African carvings are intended to be realistic. The figure or the mask does not portray a particular person or animal but conveys the essence, the spirit of that person or animal. As has been stated earlier, the primary purpose of African art is religious and its intention is to increase the life-force. The carved figures and faces are a means to this end. To the negro, strength (the head), the connection with the earth (the feet), and fertility (navel, breasts, genitals) are of the greatest importance, and that is why they are accentuated. But they are accentuated in such a way as to provide a harmonious and gratifying composition, far removed from the monstrosity that we recognize in human deformity or disfigurement. If there is harmony in what is ugly, it can even become beautiful.

Figures and masks rooted purely in tribal traditions, inspired by a spiritual ethos, and made by real artists have become rare. This is due to many causes, the chief one being social disorientation. The slow but sure increase in communications with the Western world—whether because the negro has entered Western society or because it has sent its representatives into his world—has eroded the negro's spiritual confidence; and his faith in ancient beliefs and customs has been shaken. He has not become westernized. The ancient tribal traditions are too strong for that. But he is hovering between two worlds and that has had a harmful effect.

Not infrequently he finds that representatives of Western culture want to buy the products of his craft for money or some other desirable commodity. He is amused and sees the chance of an attractive deal. At one time he used to sell some of his authentic masks and figures, sometimes as a result of extortion or trickery, although no amount of money or sweet persuasion would make him part with certain of them. In this way thousands of carvings found their way into Europe and America. Skilled craftsman that he is, he would make new ones for his own use. But these would meet the same fate, and the demand would continue to grow. The process was stimulated by the museums who collected masks and images as curiosities; and then came the artists who appreciated the beauty of African art and themselves became collectors. They were followed by art-lovers, swept along by the general enthusiasm, and dealers out for profit. More and more museums and collectors began to buy. Negro art became publicized in books, on

television, in films and on the radio. African figures were used as decorations in modern interiors which were featured in fashion magazines. The figures of ritual were prostituted as decorative objects, mere 'conversation-pieces', the subjects of highly-coloured anecdotes at sherry parties.

So at present the quality of African carving is declining. The market is flooded with masks and figures made exclusively for Western (bad) taste and with fakes manufactured in Europe. They may still bear the odd tribal characteristic, so that they can sometimes be identified. But such elements are often used for decoration over the whole object instead of in the appropriate places. The pieces are placed on stands which are entirely un-African. The figures either acquire an alien naturalism or they so exaggerate the features of genuine masterpieces that the original harmony is completely disrupted. The negro sculptor who has succumbed to fashion has either become a kind of skilled worker at the conveyor-belt or is to a greater or lesser extent producing fakes. He will make figures and masks on demand; if necessary, those of other tribes. He is by nature a deft, able craftsman but his art is blunted by the increased demand and his products bear witness to this. Nevertheless, there is always a ready market for them, even among dealers who specialize in ethnographica and ought to know better. And the dealers will sell these worthless symbols of bad taste at unscrupulous prices; in our affluent society there are plenty of people with bulging wallets and empty heads . . .

There are, of course, dealers who are aware of the situation and who value their reputation. However, on the whole the lure of profit is such that they, too, will compromise, and alongside the very rare pieces of quality they will offer corrupt pieces for sale. The irony is that as a result one might sometimes be able to purchase the real thing at a lower price than would otherwise be the case.

For the person seriously interested in acquiring African primitive art, then, the conditions are not favourable, since there is little of any worth to be had. But visits to museums and private collections can be very rewarding and there are books with magnificent photographic material illustrating pieces that are mainly good. Yet even here we have to be on our guard, for such works can be marred by the inclusion of dubious pieces.

Everyone who is interested should expose himself to this non-European art by seeing as much of it as he can. It is important to begin by looking at good pieces, in kind or in reproduction, so as to develop one's critical faculties along the right lines from the start. Once the discernment is there, the bogus forms will immediately be recognized for what they are.

One should start by examining carefully whether the figures or masks have been used. The more they have been used, the more likely they are to be authentic and valuable. Just as furniture acquires a beautiful maturity by extensive use, so these carvings acquire their patina. It can be due to weathering, or to wear in places where the figure or mask is gripped or worn. This is easily discernible, especially on the insides of masks. But there

can be plenty of artificial patina as well, though, produced by polishing and colouring and intended to suggest age, or at least use. However, the expert should be perfectly able to distinguish between the fraudulent and the genuine. Here, too, experience means expertise. Sometimes the patina consists of paint or the residuum of libations and the like, and it may be very difficult to establish whether it is authentic or not. Great caution is needed whenever oil-paint is found. Genuine paints will be ochre, kaolin, bone-black, indigo and pigments of this kind. But, as we have seen, the use of paint can be an indication that the piece is modern. The Senufo and Bambara tribes, for instance, only rarely paint their carvings, whereas modern pieces are quite often painted. It is suspicious if the layers of paint or crust can easily be removed, while a firmly embedded, rock-hard crust, covered with fine cracks, justifies confidence. It is, however, dangerous to generalize. The well-known Reckitt's blue has been known in Africa since the beginning of the last century, while an 'old' patina can develop in a relatively short time and through intensive use. A fine piece might well turn out to be recent and an early piece may look entirely new if it has done virtually no service. But in any case, the counterfeiters stop at nothing and when faking a valuable carving they will spare no cost or labour to make the new seem old. Only experience can tell here, and one's judgment of a piece will largely depend on an awareness of its proportions, which will entail familiarity with known authentic pieces in museum collections, books and so on. To the connoisseur of African art most of the fakes are truly primitive in the sense of being crude, coarse, and without any artistic sense. Above all, experience teaches us the truth of the saying, *in dubio, abstine*: when in doubt, let well alone.

All the masks and figures illustrated here are authentic, most of them having been found in the western Sudan, and it is quite certain that none of them were produced for commercial purposes. They have all been used intensively and their patina bears this out. Though their primary purpose is to illustrate this introduction, they are accompanied by short descriptions of their origin and function which I hope will be of value to the reader.

# MASKS AND FIGURES

THE Dogon tribe inhabit the escarpment near the bend in the river Niger, on the southern edge of the Sahara desert. High rock formations are their natural line of defence and account for the fact that Dogon culture has remained virtually unaffected by the cultures of neighbouring tribes. The legend has it that prior to this Dogon settlement—which supposedly dates from somewhere between the thirteenth and the fifteenth century—the area was inhabited by the Tellem ('small ancestors') who are supposed to have been driven out, or to have migrated to the south-east. Whether or not there is any truth in this legend, it is a fact that so-called 'Tellem' figures have been found in the Dogon region, which differ from the current Dogon figures in form and spirit. However, there is also a kind of transitional style so that it can be argued that the 'Tellem' figures are orthodox but earlier Dogon figures. This would more or less tally with the findings of the radioactive-carbon (C-14) method from which it appears that the Tellem figures also date from about the thirteenth century.

The Tellem horseman depicted here (21 cm) is not just an ordinary rider but represents a transcendental creature (Nommo), an envoy of the creator-god Amma mentioned in the Dogon myth. The figure is somewhat reminiscent of the Italian sculptor Marini's horsemen, in that they too did not represent ordinary riders.

THIS Dogon mask (height 68 cm) is comparatively rare and displays an impressive severity in its general appearance and its peculiar structure. It is composed of vertical and horizontal lines though the overall effect is not one of rigidity. Like most masks, it presumably formed an integral part of the ritual of the dead and was connected with the prevailing myth of the tribe.

It is not clear, however, what is represented here. The mask may represent an elbow or a stirring-spatula, and in either case it would symbolize labour as one of the tribe's inherited gifts. But we must avoid the danger of romanticizing. Alternatively, the mask may be a symbol of perseverance and good will.

As regards colouring, only black and white are still distinguishable. The zig-zag marking could refer to all kinds of things; it could represent water or it could symbolize the contrasts in nature or human existence: for instance, order and chaos, good and evil, man and woman, water and fire, or heaven and earth.

FOR the Dogon, who inhabit a relatively poor and infertile region, millet is the staple diet. The grain is carefully harvested and stored in granaries which are sealed off with small doors. These doors are often carved with ancestor figures and millet seeds, a symbol of fertility. According to the Dogon myth, Amma, the creator-god, took clay and fashioned from it a pair of humans who brought forth eight ancestors who were immortal. These eight ancestors produced eighty descendants who spread out over the Dogon world. The door in the picture (60 cm high) has five figures in each of the panels. Since it is only a fragment of a complete door, there are likely to have been figures on the upper and lower panels of the rest of the door. It is very old and the surface has acquired the appearance of elephant hide. It is a beautifully rhythmical composition with its rows of stylized, even faceless, ancestors with their arms stretched out above them. Such a posture is quite common among the Dogon—and in particular among the 'Tellem', and it is thought, though there is no certainty about this, that it implies a plea for rain.

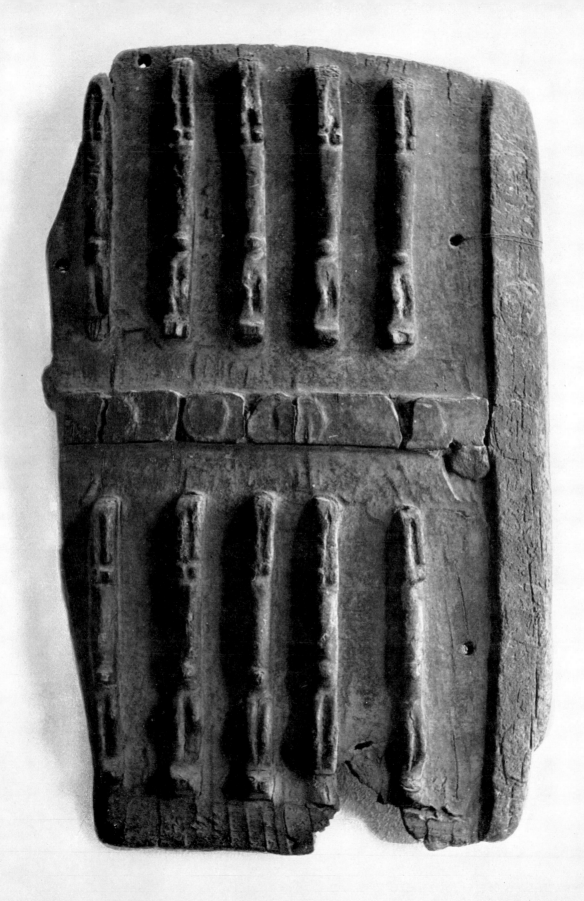

THIS mother and child (height 30 cm) is a typical example of the 'Tellem style', with an aura very different from that of the Dogon carvings. The Tellem seem to have had a much more gentle nature than the Dogon, who prefer an angular style with pronounced facets. The Dogon found Tellem images in the caves and hold them in high esteem, attributing great power to them.

Unfortunately, many of the Tellem images were unscrupulously taken from the Dogon people by ethnologists and dealers; and Dutch expeditions of the last few years have failed to discover any residual Tellem figures of note. This Western exploitation has meant that in large areas of Africa, art has been declining rapidly, because of the absence of worthwhile prototypes and the influence of Western ideas.

In this figure it is the harmony that is striking, the sensitivity of the interrelationship between vertical and horizontal lines, the strong, aristocratic thrust from the neck to the body and from the chin to the ear. The swastika-like stance of the child against its mother's back is strikingly natural and completes a *maternité* of remarkable beauty.

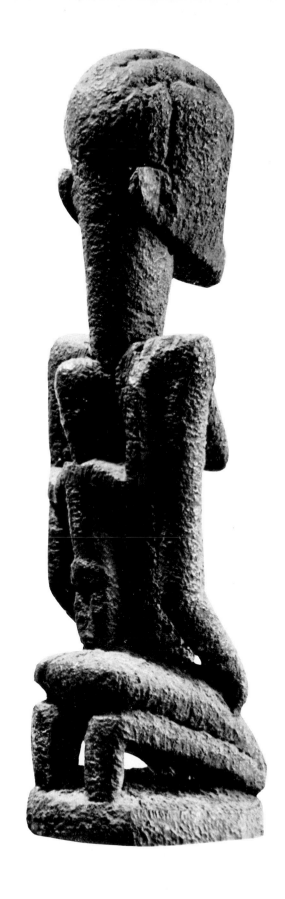

A SIZEABLE 'Tellem' figure (height 59 cm) with an extremely hard, crackled, light-brown patina. Tilted back with arms outstretched the figure seems to represent an attitude of urgent pleading, which might imply that it is customary in this barren region to pray for rain when the end of the dry season is in sight. But, as has been stated, it is still not known whether such an interpretation is correct. The figure represents Nommo, a demi-god, who is said to have descended to earth with an ark (!) containing the eight ancestors as well as animals and plants. Nommo is the embodiment of goodness, of order. He is in possession of the word, and he will teach people the word and the technique of weaving—two things closely connected in Dogon thought. The Dogon myths relate that the ark did not make a very soft landing, which accounted for Nommo being injured. The figure's one mutilated arm may, therefore, well be deliberate.

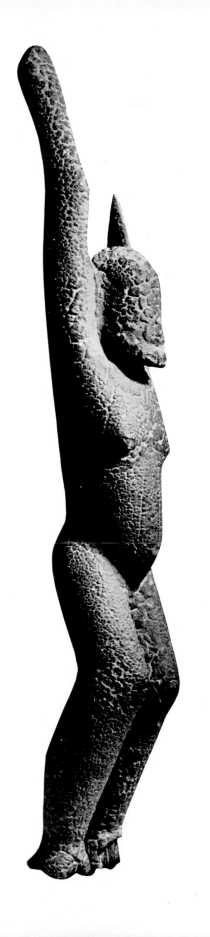

FROM the preceding commentary it will be clear that this image (height 40 cm) is of Dogon origin and displays the familiar suppliant attitude with arms stretched out above the head. Nevertheless, its impact is different. The monumental composition has formalized the pleading gesture and the parts are much less related. It is, however, typically Dogon in its crossing of vertical lines and its stylized contours. The piece might indeed be an example of a transitional style coming between Tellem and Dogon. The massiveness from the waist up and the creation of the spaces between the arms, the hands and the head is quite masterly. The very hard, grey, granular patina also imparts a stone-like appearance to the figure. The back is much smoother with a grooved surface suggesting exposure to weather or scarring by sand and water.

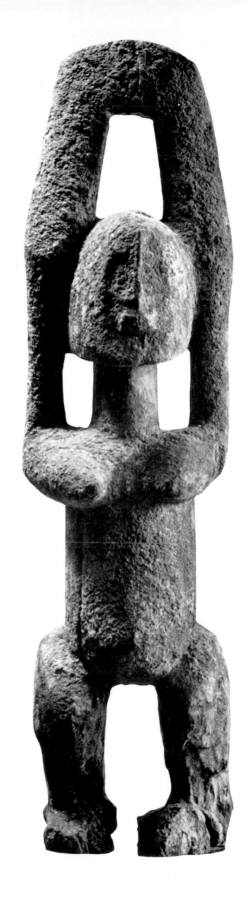

A FRAGMENT of a Dogon image (height 43 cm), but even so, important enough to be included here because it so clearly exemplifies the Dogon style. Though obviously a female figure, it may well represent a hermaphrodite ancestor because of the quiver—a traditional attribute of males—carved on the back. The front of the face is greasy and worn nearly smooth, probably by hands repeatedly caressing it, an action of ritual significance in Africa as in other parts of the world. There are a number of perforations on the rim of the auricle, which once contained aluminium rings. These were not merely decorative but part of a girl's education towards womanhood. The perforations were intended to facilitate the passing of the 'right words' into the ear. But this only took place after the girl had learned to close her ears to the 'wrong words'. To that end, the perforations were initially filled with small wooden pins, which were then later replaced by the rings.

In the carving there is a marked preference for the cylindrical form (body, arms, neck) and the cone (breasts and the shape of the head, broad-based and tapering). There is a pronounced sense of harmony in the three cylindrical horizontal planes, set in apposition and opposition, capped by the horizontal line of the head, and linked by the verticals of hair-style, neck, body and arms. The patina shows signs of many libations, and in several places metal objects have been inserted into the figure to fortify the life-force of the image.

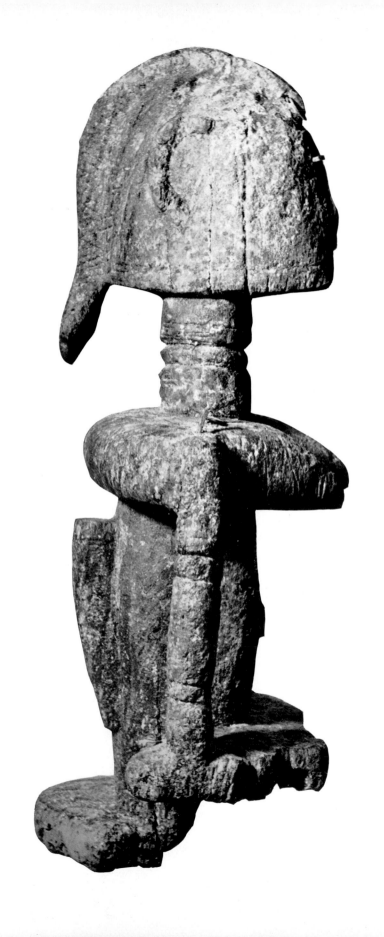

THERE can be no doubt that the Nommo-figure here (59 cm high) belongs among the Tellem images, the so-called rain-worshippers. Another interpretation of this type of figure is that it was intended to illustrate the myth of how the human body is divided into limbs in order to be able to work. It is not a carving fully in the round since the body stands out in relief against a flat background, which makes the arms appear to have issued straight out of the legs. There is none of the pronounced planar style of the Dogon, the contours flow, and the whole emphasis is on the upward aspiration. This Nommo is sometimes portrayed with one arm, or one leg, sometimes with three of four arms, depending on the local version of the myth or on the particular episode of the myth that is represented. The patina, dark brown with remnants of offerings (probably cream and millet), is covered with the tooth-marks of rats which have obviously relished these remnants.

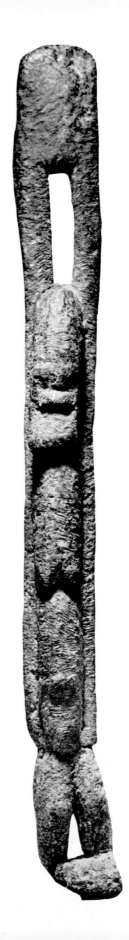

A DOGON group-carving (height 30 cm) of a man and a woman, recognizable by the tattoos, scarcely visible in the illustration, on the sides of the heads. The group is not meant to portray just any man and woman, nor a family-group nor eternal love, but the first human couple, created by Amma, the creator-god. There cannot be many instances of this union having been represented as so timeless, so close-knit and so monumental. They are two separate creatures, but the gesture of the arms and the hands facing each other (and how right not to entwine them) binds their two independent natures in a new union. The other two arms are stretched upwards in a ritual attitude. These arms do not start from the shoulders but from the hips, yet the transfer is so inconspicuous as to be the sign of a true artist. Another masterly feature is the smooth flow from hips to legs; it is almost impossible to see where the one ends and the other begins, yet there is nothing strange about it. Indeed, nothing else could have been so right. It is hardly surprising that pieces like this have made such an impression on modern sculptors that they have tried to achieve similar formal perfection.

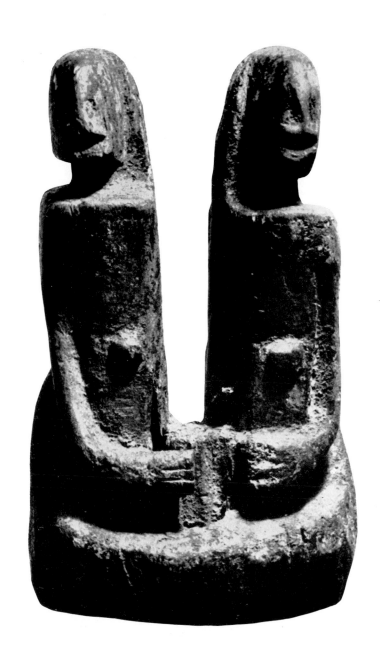

A FAIRLY rare Dogon mask (height 64 cm) representing the hunter. It is a remarkable composition that is not easy to define. Above the large oblong eye-sockets is a bulbous kind of bird's head, with its snout running into the nose of the human face. Two small sticks serve as teeth in the mouth. Whether the bird's head is meant as such is not clear; it could also represent a human face. The nose and mouth are surrounded by a strip of hide with hair on it, and the entire mask is covered with a granular patina of sacrificial blood. According to the French Dogon scholar Griaule, the mask originates in a complex myth figuring the hare, the hyena and a hunter. In the dance where this mask is displayed, a hare's mask is also used, and this goes into hiding while the dancer imitates the actions of the hunter. It must be fascinating to see this mask in action.

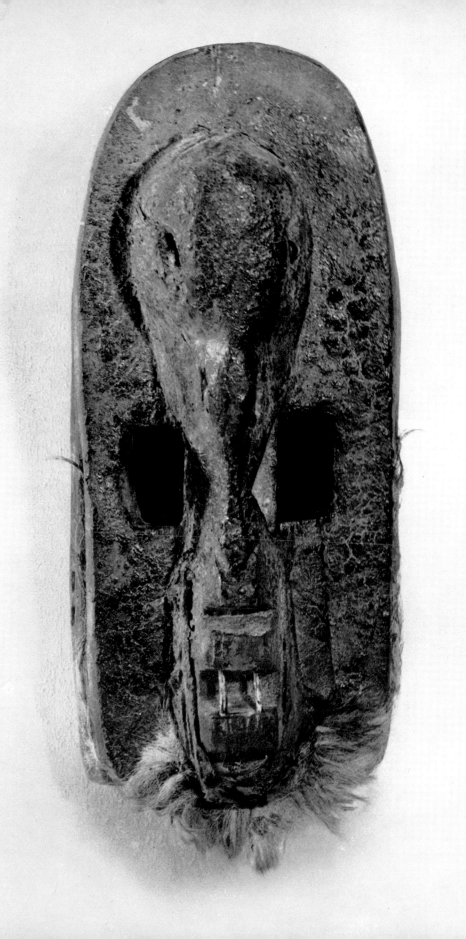

ONE of the strangest Dogon masks is the so-called Kanaga-mask, used at important events in Dogon life, e.g. during the wild dances on the roof-terrace of a prominent deceased member of a secret society, or during the preparations for the sowing of the crops at the beginning of the rainy season. The black and white mask is an abstract image of the human face consisting of such clearly defined horizontal and vertical planes that it appears to be a construction designed to catch the incoming light and throw mysterious shadows during the dance.

The 'Cross of Lorraine' on the mask probably represents a bird in flight, but it has also been described as an abstraction of a crocodile, in Dogon mythology one of the first animals that they encountered, and on whose back they crossed a river. According to one interpretation, the cross even has a cosmic significance since it represents the balance between heaven and earth. It is surmounted by two figures portraying the first human couple. During the dance the ground is touched with the top of the mask and this is said to represent the creator's movements on his course. It is evident that the purport of the mask (height 100 cm) is extremely complex and charged with Dogon mythology.

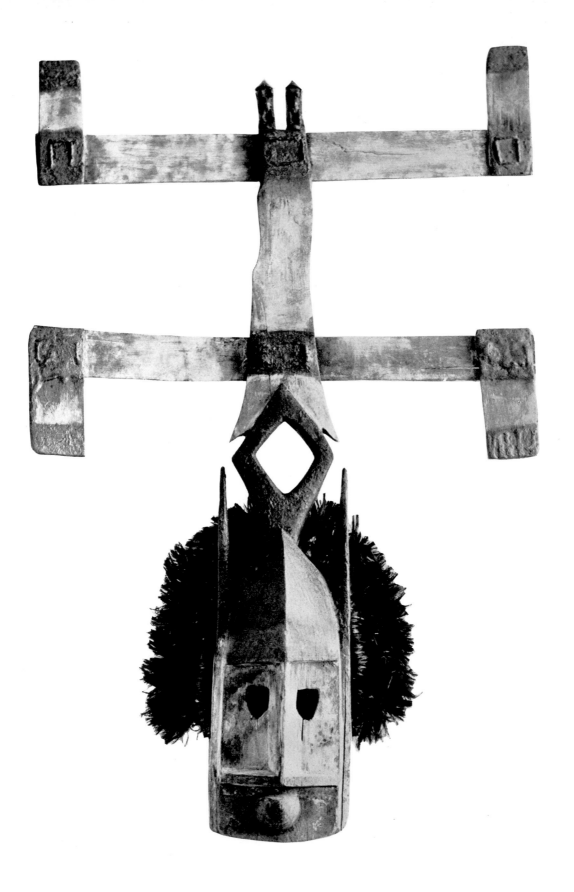

IT IS usually possible to determine the origins of a carving by characteristics which link it with a certain tribe. But sometimes it is impossible to avoid an approximation of some hundreds of miles. This mask (height 72 cm) is a case in point, for it could belong to either of two cultures, the Senufo or the Bambara. The shape of the mouth, nose and eyes suggests Senufo influence, but the ears are typically Bambara. So any deductions about its use would be questionable. We do not even know whether it was used horizontally or vertically. But it is certainly a very mysterious mask: witness the handsome shape of the eyes and the magnificent curve of the eyebrows flowing into the line of the nose and cheeks, and the terrifying jaws with their large teeth. The patina shows the natural mellowing and colouring of very old, cracking wood.

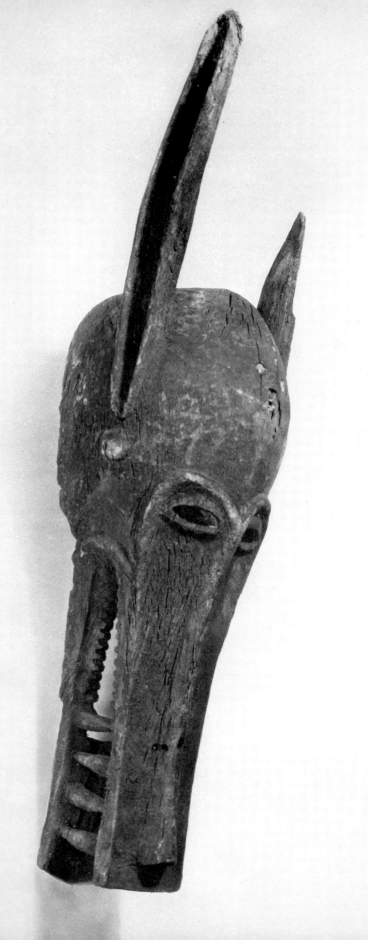

To the south-east of the mouth of the Niger is Cameroon, an area inhabited by many tribes, whose carvings are similar in that they all express motion, an element which is absent from the vast majority of carvings of other African tribes. There are, of course, transitional styles, though, as in southern Cameroon, bordering on Gaboon where the sculpture is much more static. Generally speaking, the figures and masks are designed for their effect rather than for their religious insights. They often exemplify the power and might of local rulers or tribal chiefs.

The purpose of the drum shown here (length 65 cm) is not known, and there is no point in indulging in romantic philosophizing about it. But it is worth pointing out the suggestive power of this carving. Even without the devil's heads placed one at each end. the drum conveys the impression of an unyielding animal, and one cannot help sensing the effect such a mass of primitive force must have had whenever it was drummed.

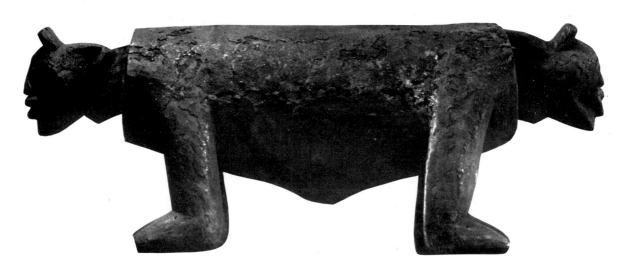

THE region between Ghana (the Gold Coast) and the Niger estuary is inhabited by the numerous Yoruba who differ from most other African tribes in their extensive use of colour for both masks and figures. The world of their religious beliefs is peopled with many gods and demi-gods, all represented in their carvings, which are fairly realistic. Twins, for instance, are considered sacred and are thought to be protected by a special god. The Yoruba believe that they have one indivisible soul. When either of the two dies, images are made of both of them. The figure of the dead twin is bathed and washed and generally treated by the mother as if the child were still alive and when the surviving twin is old enough he or she takes on this task. After the death of the surviving twin the figures are kept in the family for years.

The figures opposite (which are in the characteristic style of Ila-Orangun) have a height of 26 cm, their head-dresses are indigo-blue and the bodies have been rubbed with red cam wood and palm oil. The faces are dark brown. The typical proportion of head to body indicates clearly that the head (the intelligence) was considered the more important.

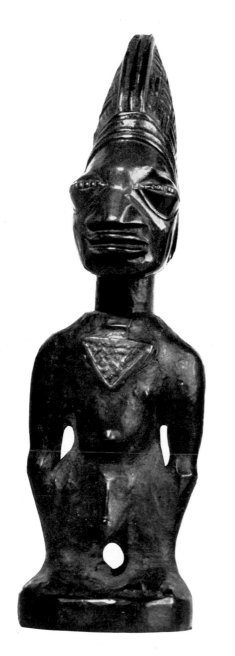
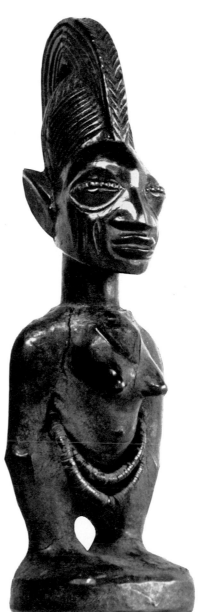

A BOY'S mask of the Bambara tribe, used in the so-called N'Tomo society, which dominates the boys' lives until they can be admitted to the men's societies. The mask's main function is at harvest festivities and other farming seasons. It has certain special uses and also acts as a protection against evil spirits and disease. The N'Tomo society is one of the oldest societies and is closely connected with the story of creation as it is known to the Bambara.

The face of the mask is surmounted by anything from four to fourteen horns (symbolizing fertility, and often accentuated by the decoration of the entire mask with cowrieshells and red seeds). The number always has a symbolic significance. Four is the female symbol, seven for male and female, six (as illustrated) for male twins and eight for female twins. This old mask (height 40 cm) has a hard patina of residues from sacrifices, and the inside is worn smooth by frequent use. It has a very strange, almost unreal air about it, suggesting something of an animal skull.

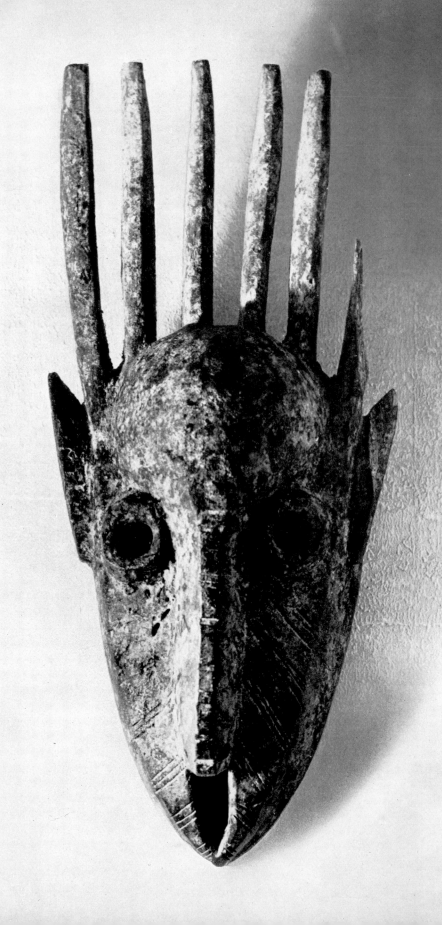

THE style of this dignified figure (height 79 cm) suggests that it is connected with the fertility rites of the Malinke, a branch of the Bambara tribe living to the south-west of them. There is a similar smaller version (*ca.* 45 cm) in the Kjersmeier collection and there the head and the flat surfaces of the forearms are covered with fertility symbols (cowrie-shells and seeds). It is quite possible that this figure, too, at one time carried these symbols and that they were removed at a later date by collectors, as has been known to happen elsewhere. Since the precise object of the sculpture is uncertain, undivided attention can be given to its superb structure: the harmonious relationship of curves, planes, cylinders and cones comes to life in an impressive human figure.

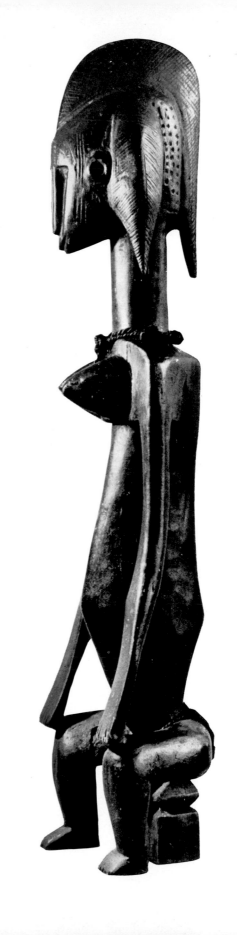

THE stylized antelope here (length 62 cm) is a so-called *Chi wara* head-dress of the Bambara tribe, and it comes from the district of Bamako in the north-west of the Bambara country. *Chi wara* means 'the animal that works'. It represents a mythical antelope, created by Faro the supreme god, and it was dispatched to the earth to teach man how to till the soil.

This type of mask belongs to several groups of young men in the period between youth and adulthood. It is used at the initiation of a new field or at the beginning of the rainy season. The masks, carrying their strength and vitality with them, accompany the labour force to the fields so that they can supervise the work. Afterwards they always return in pairs to the village (male with female antelope) to perform a fertility dance. With these masks (with horizontal horns) the head of the antelope is attached loosely to the neck; which is very unusual, for African carvings—whatever their size and no matter how intricate their structure—are otherwise always carved out of a solid block of wood. The head-dress is fixed on the head with the help of a wickerwork cap.

The mask in the illustration has obviously received many sacrifices, and from these and the smoke in the huts it has acquired a rich chestnut patina. This specimen is a remarkable example of vitality, mystery and harmony.

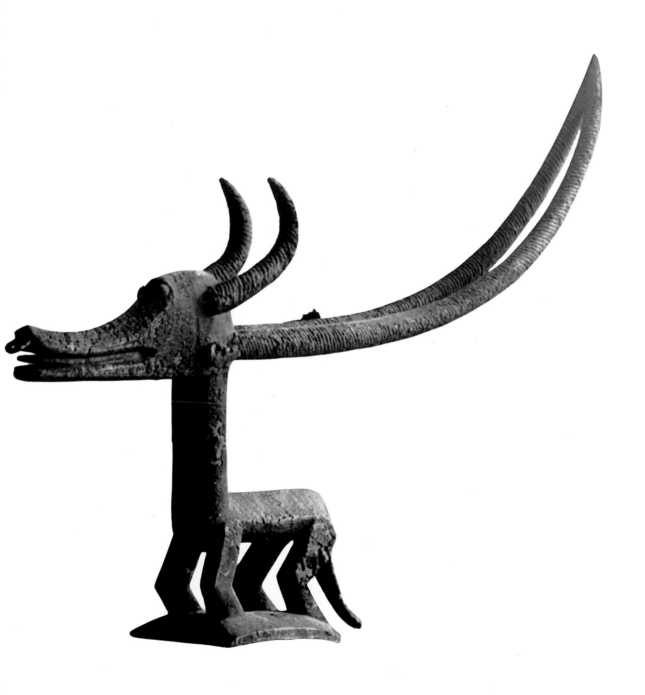

IN CONTRAST to the preceding head-dress, the *Chi wara* (height 58 cm) depicted here, from the north-east of the Bambara country, is carved from a solid piece of wood, although the local repair—necessary because the body was broken in two—might lead us to think otherwise. There are also signs of local repairs on the nose and on the antelope's left leg, where termites have been active. The horns of both mother and son are upright and the young antelope proudly shows its beautiful, growing mane and its small, lightly curved horns. The horns of the female antelope are always completely straight. In this group the first thing to strike the observer is the harmony of the lines and the close unity between the two animals, while tenderness and poise impart nobility to it. The carving has a natural dark-brown patina and gives off a sweet, smoky aroma, due probably to frequent applications of oil or wax, solid traces of which are still visible in the grooves of the horns.

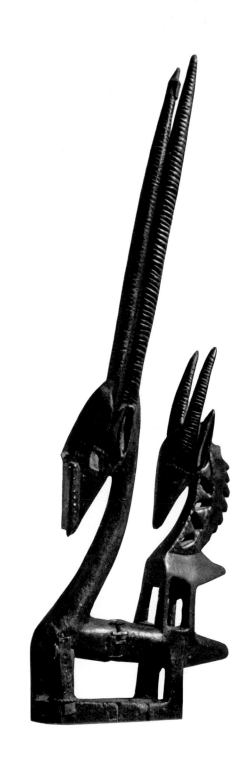

As well as the N'Tomo young-men's society, referred to on p. 52, there is the Koré society, which is connected with the harvest. Its main purpose is to pray for rain. Koré is a god of nature, the god of growth, who is commemorated every year, with a special feast every seventh year. During the rites the mask is the custodian of the secret, and guards the ceremonies against uninitiated intruders.

The specimen shown here is among the finest that have been found, judging by the sensitive eyes, the delicate ears and, above all, the masterly line of the head, going from the vaulted forehead to the tip of the nose, continuing by suggestion as far as the lower lip, supported by the cheeklines running parallel to the lines from the ears, and also continued down to the lower jaw. The mask makes a dramatic impact, however unintentional, and judging by the patina, it has been worn a great many times. Although representing a very stylized hyena, it has decidedly human features. This combination occurs quite frequently in African masks and it is all the more remarkable for being so self-evident and devoid of any dissonance.

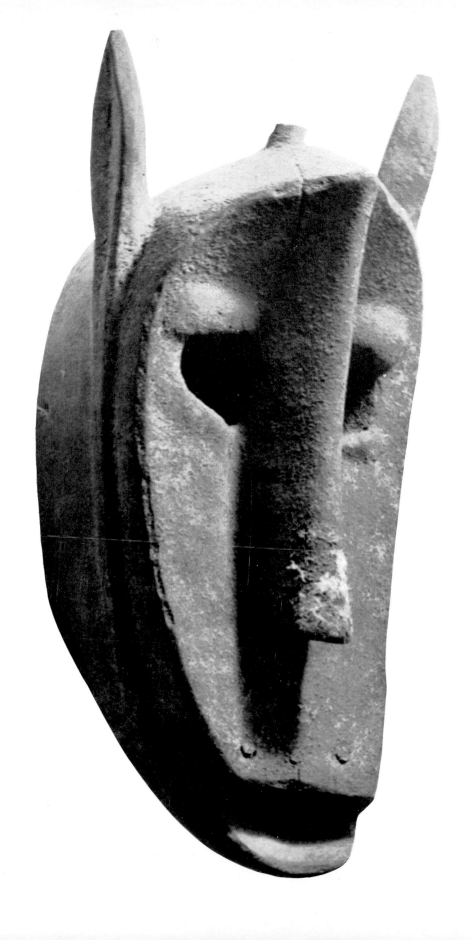

MANY of the masks adorned with horns, ears, bulges and so on are connected with the process of growth everywhere in nature. For primitive peoples this process is paramount in the life of man, particularly in areas where infant mortality is high, where the land is infertile, and where the tribe is engaged in a constant struggle for survival. In the Bambara myths, the antelope, as we saw earlier in the *Chi wara* head-dress, is closely associated with agriculture; so too in this mask of the Malinke, thought to be one of the Bambara tribes. All adornments—for instance cowrie-shells as symbols of growth and fertility— have unfortunately been removed, but we thus have a better opportunity to observe the interesting resolution of contrasted surfaces. Although it portrays an antelope, this type of mask has stylized reality to such an extent that it has become an abstract figure. Its height is 45 cm.

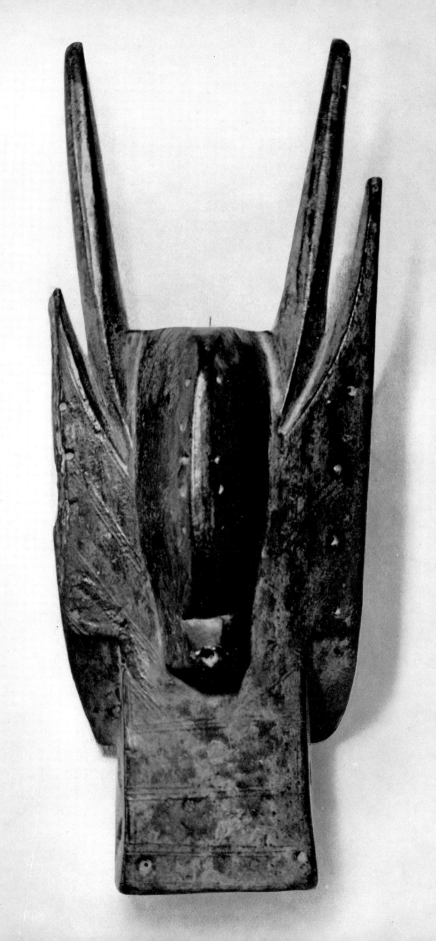

THE early piece depicted here is an owl-mask of the Bobo tribe. It is 85 cm in height and it has lost most of its colouring. The whole thing is rust-coloured with occasional faint traces of white and red. This mask too is used at agrarian rites, and in particular to ensure a favourable outcome of the hunt. The owl is, after all, a great catcher of mice! The mask is also used at the rites for the dead to clear the area of evil spirits. Which explains the aggressive wide-open beak and eyes, and the (missing) hook above the nose for piercing evil spirits. The heraldic patterns symbolize the earth and the water, and the moon-symbol signifies increase and growth.

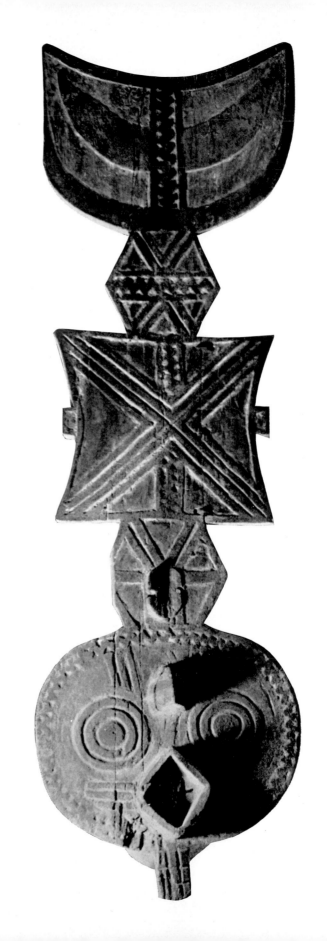

THE Poro society is powerful in large areas along the west coast of Africa and its influence can be seen alongside the distinctive tribal styles. In this, as in many secret societies, there are different grades that are open to its members and each man will do his utmost to obtain a higher grade since such societies are very influential in the political and socio-economic life of the community. The Poro mask may portray a completely human face or an animal face, or it may be a mixture of both. It may have an entirely stylized simplicity, but it may also display striking expressionistic features. The early mask illustrated (height 25 cm) shows the latter characteristics in its very pronounced protruding mouth, large nose, striking cheeks and overhanging forehead. Together, these produce an impressive, severe and, at the same time, dramatic effect, reinforced by the beautifully hooded eyes.

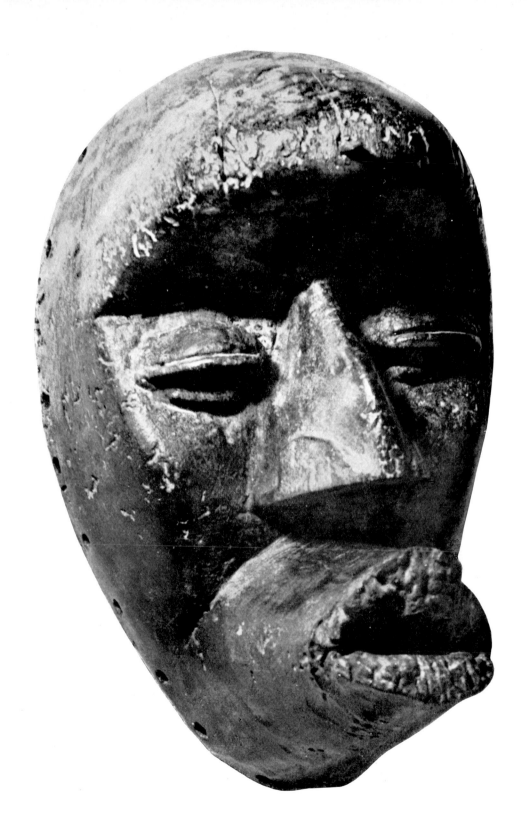

THIS Dan mask belongs to the same Poro society, whose ambit includes many tribes along most of the west coast of Africa. The society does not have its own particular mask, but each tribe has certain masks that express the Poro ideal in terms of its own tribal characteristics. In this case it is a so-called bird mask (height 28 cm without beard), completely covered in some textile and daubed with red paint and chewed kola-nuts. The mask has been so much used that the fabric, wherever it is exposed—e.g. on the nose and sides—is scarcely recognizable as such and looks like wood. The inside, deeply hollowed out, has acquired a smooth, polished surface from intensive use. It used to have a bunch of feathers on the top of the forehead. The beard is made of monkey hair, and the lower jaw is moveable.

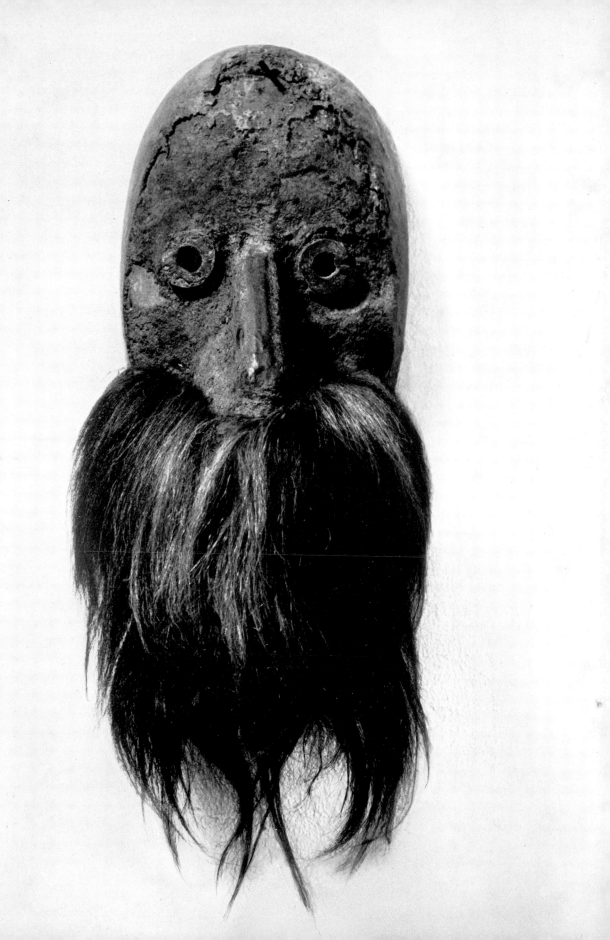

A MASK (24 cm without beard) of the western Dan tribe (near the Liberian border) that is very similar to the one shown on p. 66; but it is not certain whether both masks fulfil the same function or whether this one is rather an initiation mask of the Poro society. The keloid dividing the fairly flat forehead, and continued by the nose, forms a cross with the narrow line of the eyes and this effect is accentuated by the severe and yet sensitive mouth. Although the mask is itself very fine, it has weathered to a dull rust colour, and has none of the patination usual on Dan masks. Its setting, in a pale, wine-red cloth and brown, plaited beard, heightens the general impression of great dignity.

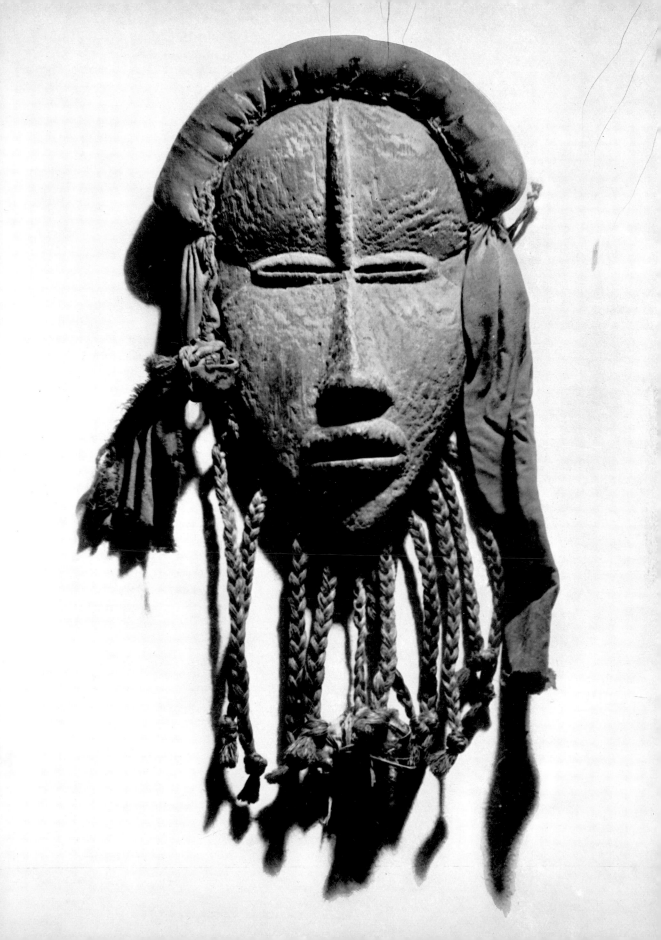

THIS bird mask is an exceptional type of Dan-Guere mask (28 cm without beard). The beak, rather like a duck's, is beautifully shaped, with a rich, dark-red patina and a few small aluminium teeth. It is not clear what the mask is used for. As a rule, bird masks belong to the category of 'village guards', but it is possible that a particular carver just took it into his head to show what he was capable of by way of a change from the customary bird masks. It is a striking instance of an explicit combination of human and animal features, an expressive carving with bold, projecting shapes, producing a perfect blend and unity. The parallel curves across the cheek give an essential emphasis, and when seen from the front they lend such a comical expression to the face that the impious thought of Donald Duck comes to mind!

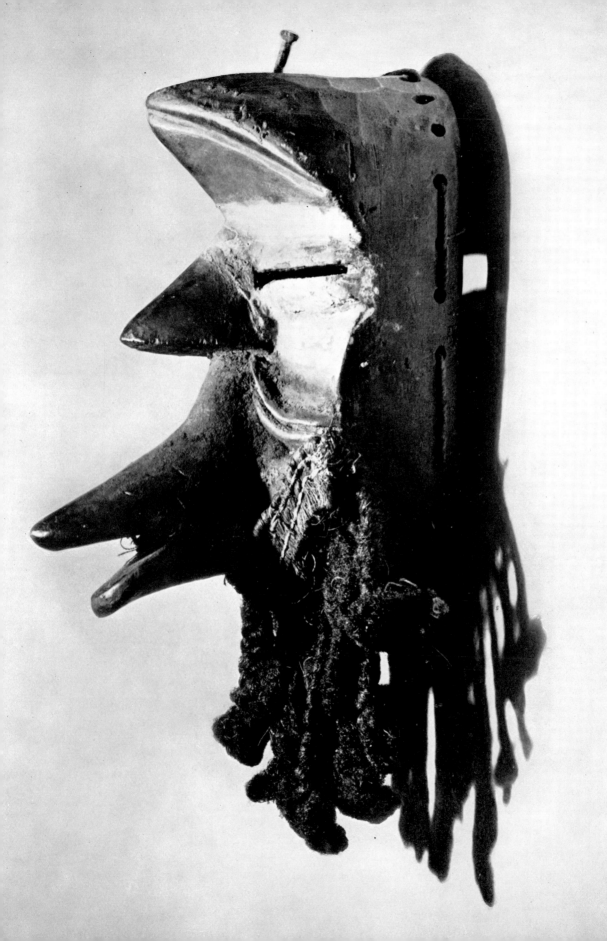

THE Dan mask (height 18 cm) shown here is a so-called mother-mask, used exclusively by members of the Poro secret society. The wearer stands on stilts and is concealed behind a garment reaching to the ground. Striding through the village, he chants his exhortations, wise counsels and commands in a voice that seems to reverberate from the shades. The mask settles disputes, guards chastity, controls labour and protects the community against enemies. It radiates great gentleness which flows from the clean centre line, the beautifully shaped eyelids, the soft moulding of the cheeks and the expressive mouth. It has moreover a most attractive pale-brown patina. The Dan make some of the most realistic masks there are. The vertical line down the forehead and nose, for example, is a real tattoo mark of the Dan tribe. Masks of this type aim at great purity of expression.

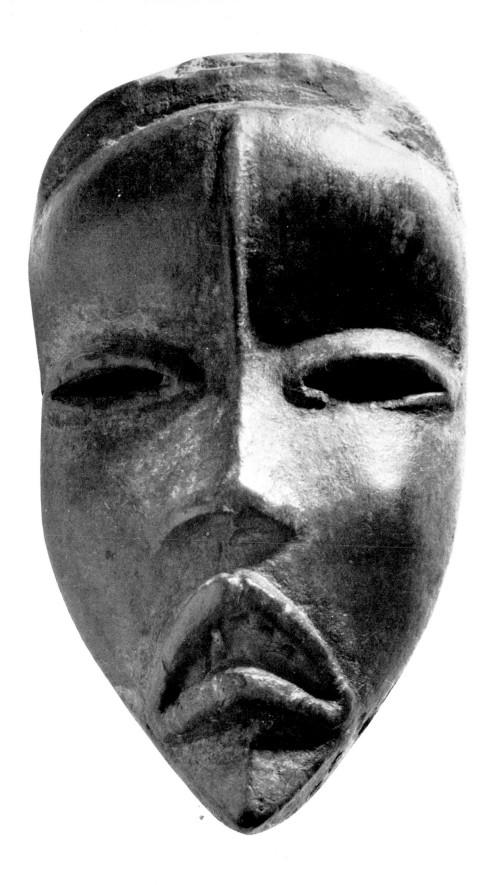

THIS mask (height 80 cm) comes from one of the most northerly tribes to have developed carving, a branch of the Baga tribe. It is called Nimba péfète. It belongs to the Simo society and is used at the rice harvest and at burials. The Simo society controls and dominates the tribe's social and religious life. We must envisage the mask fixed on the head of someone concealed behind a full-length garment, which is attached to the base of the mask, leaving its breasts bare. A figure clad thus must convey great mystery and majesty as it emerges from the forest, displaying at its summit (at a height of at least seven feet) nothing more than the small, exquisitely shaped head and the front of the mask. The wearer of the mask would be looking through the hole just under the breasts and holding it by the 'legs'. The mask is black with a lovely patina from frequent use. It is one of the most beautiful of its type and in effect completely 'modern'.

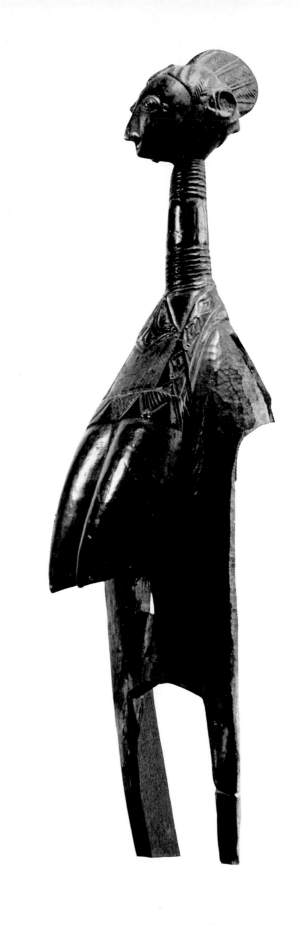

THE Kurumba live in an area to the south of the Dogon tribe and, as we mentioned earlier, they may belong to the Tellem tribe who are said to have been succeeded by the Dogon in the rocky region of the Niger bend. A number of Dutch expeditions have tried, so far unsuccessfully, to find a definite answer to this question. Although 'Tellem' images are well known, there is no knowledge of the existence of any Tellem masks; whereas we have Kurumba masks, but no images. Moreover, the general tone and craftsmanship of these masks has nothing whatever in common with Tellem figures. Be that as it may, the only famous Kurumba mask type is a fairly naturalistic carving of an antelope—much more naturalistic, that is, than the antelope masks of the Bambara tribe. The mask is said (though not very definitively) to be used at the end of a period of mourning to drive away the ancestral spirits. Some students have suggested that only about twelve genuine masks are extant and that the many new ones which have appeared on the market are being produced solely to satisfy the demand for them. The mask depicted here (height 117 cm) is said to be of the latter type, but even so it is a particularly fine specimen with an aura of mystery, despite its naturalistic character.

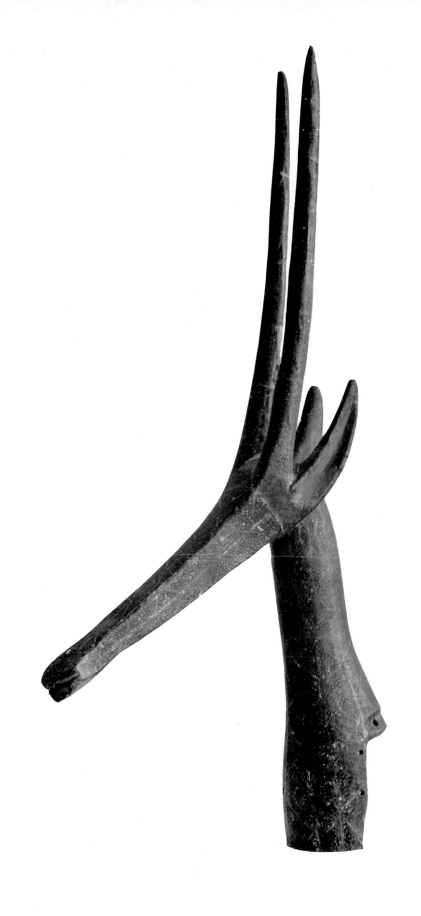

ALTHOUGH this figure (100 cm) may have been an ancestor figure, it is more likely to be the upper part of what is known as a rhythm-pounder of the initiation society of the Senufo tribe. It is used at ceremonies connected with the cult of the departed. The figure of Lo, the ruling goddess of the society, is stamped on the ground by young men recently initiated in dances during the tilling of the soil, to invoke and promote fertility, and call on the dead to transfer their vital forces to the society.

This piece originates from the north of the Senufo country bordering on Dogon territory, an area where sculpture shows a growing tendency to relate physical forms to the style of pole carvings. It is one of the very old pieces of which many were destroyed during a short-lived new cult, the so-called Massa cult. The height of the figure has been emphasized by the flowing lines from the curved legs to the narrow body, and further stressed by the long narrow spaces between the body and arms.

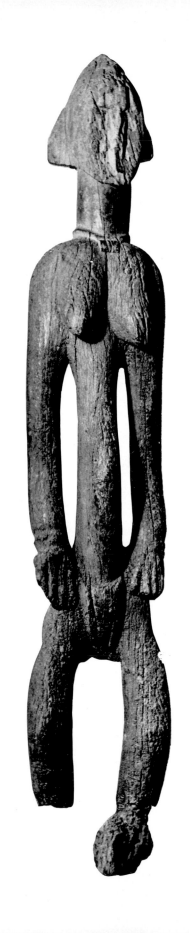

THIS bell-shaped mask (height 61 cm), carved from one block and shown here from the rear, belongs to the Senufo tribe and is carried with a procession of young men about to be initiated into the Lo society. The mask sits fairly high on the head (the rim just above the wearer's eyes) and the wearer's face is covered by a mesh of cowrie-shells, hanging from the front of the mask. This type of mask is used in the village of Sinémataili in the Korhogo district. The masks are stored in one of the village huts which may only be entered by initiates of the Lo society.

Note how the slightly raked wings, reminiscent of a beetle's wing-case, throw the salient ancestor figure more sharply into relief as she emerges mysteriously from the protective forest of feathers and porcupine's spines.

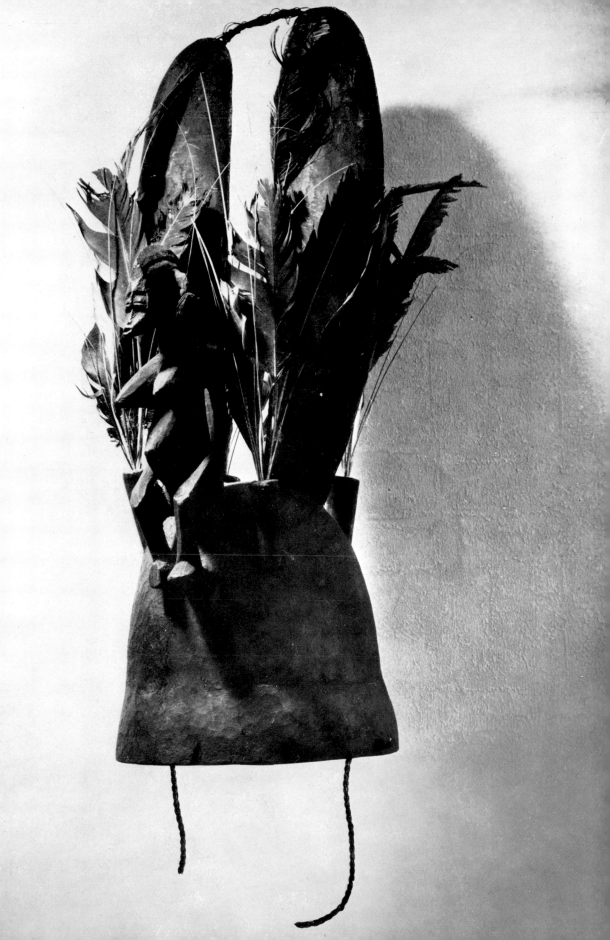

A HEAD-DRESS (height 96 cm) called 'Kwonro', also originating from the middle of the Senufo country, and used during the initiation rites of the Lo secret society. As in most secret societies, the members can continue to improve their position in the hierarchy. The Lo society has three main levels, and it takes seven years for the young men to pass from one grade to the next. So it takes them about twenty years to reach the top, and only then, somewhere between the ages of thirty and forty, are they considered to be fully adult. As is evident from the scratchings, the illustrated carving has been repainted several times, and not always in the pattern it now has. The central figure is the Senufo totem animal, gracefully fitting into the space allotted to it and yet expressing great strength, the strength of the steady grip of the legs and tail on the bottom and the powerful upthrust of the forelegs. With its fascinating markings, the whole piece breathes vitality and mystery.

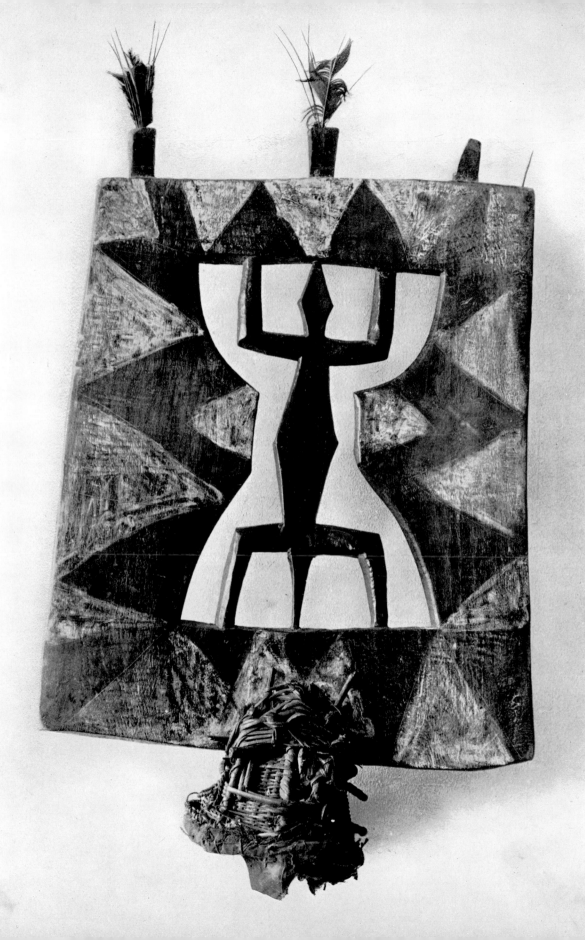

JUST as the *Chi wara* head-dress-mask of the Bambara tribe is used to promote competition at agrarian (fertility) rites, so the Senufo staff or *daleu* shown here serves as a trophy for whoever achieves the best results in farming. Not that this should be seen as an entirely material contest, for the participating young men are also members of the Lo society, so that the competition has a ceremonial character too. But the *daleu* also serves as part of the masked dancer's insignia, and is believed to have the power to repel evil influences.

The small figure (height 24 cm) is part of the staff which measures 132 cm in all. The small basin carved on top of the head and damaged at the front, would have been used for offerings. Nearly all Senufo carvings are powerful compositions like this figure, irrespective of their size. Their expressive character is due to the deliberate exaggeration of their proportions.

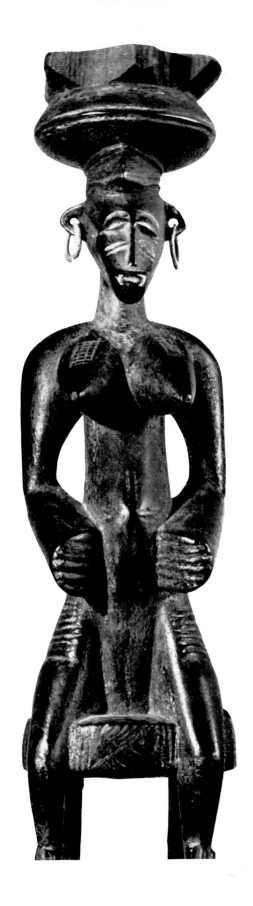

THIS is neither a toy horse (length 90 cm) nor a seat in the accepted sense of the word, but an instrument for invoking rain after drought. It is used in the north of the Ivory Coast, along the border of the Mali republic. The medicine-man, carrying the animal by its cords and surrounded by the people, will take it to the sacred forest where the multitude may not enter. Then, in solitude, he will get into the saddle and, judging by the scars on the horse's neck and forelegs, he will proceed to chastise the animal, all the time uttering certain charms intended to hasten the coming of rain. Among the Sefuno, the horse is generally connected with water, and the reliefs on the flanks may also bear this out. But from the humorous expression of the head we might well conclude that the animal is enjoying the thought that the rain will come, even without the rider's efforts. For the medicine-man is also the weather-man and he is bound to choose his moment for invoking rain. As a work of art, this is a masterly piece, simple and ingenuous, charming in line and style.

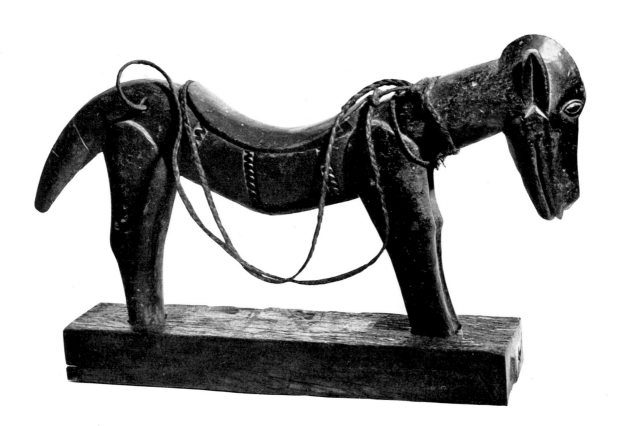

A STAFF from the Korhogo district of the Senufo tribe, likely to have been an emblem of dignity (total length 89 cm, figure 36 cm high). The best-known Senufo staffs have a different shape, the staff itself being longer and the bottom pointed for sticking into the ground. The staffs are usually surmounted by a seated female figure and they are, as a rule, awarded to the fastest and most efficient farm worker. The staff opposite was evidently also used to promote fertility. The figures carved on top of the human image (who probably represents Katiéléo, mother earth) are totem animals of the Senufo tribe, the commonest of which are the hornbill, the tortoise, the snake, the chameleon, the crocodile, the lizard and the frog. The group of figures, which is equally fascinating seen from any angle, is held in tension by a skilful balance of surface areas, an intriguing interplay of lines and an elusive air of mystery. Frequent use has left a shiny, deep, reddish-brown patina at the centre of the staff, and the group of figures is covered with the smoky remnants of sacrifices. According to Senufo sources, this particular group represents the chameleon (the earthly element) and the bird (the heavenly element), perching on a human figure who belongs to both spheres.

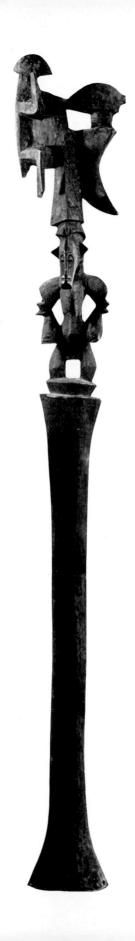

THE Ashanti, who live in Ghana (the Gold Coast), have been famous for centuries for their sculpture overlaid with gold foil and their gold jewellery. From them we also have countless small weights for weighing gold dust. These are cast in bronze or brass, and many of them are of great charm, spontaneity and vitality, masterpieces portraying daily customs, sayings, riddles, animals and people. Their wood-carving has, however, for a long time been known abroad chiefly for the *akua'ba*, the highly stylized human figures for promoting fertility, which are carried by women or girls wishing to give birth to a beautiful child—in our example a girl. The head-form is apparently also related to the Ashanti ideal of beauty, and indeed one can encounter children, especially those of high birth, who have similar facial expressions and proportions. There are vast numbers of these *akua'ba* but they are of very unequal quality. Some are coarse and grotesque, others —much less numerous—have an almost abstract beauty deriving largely from the position and shaping of the eyebrows, eyes and nose. This *akua'ba* (height 36 cm) belongs to the smaller group. On its back there is an exceptionally fine abstract drawing.

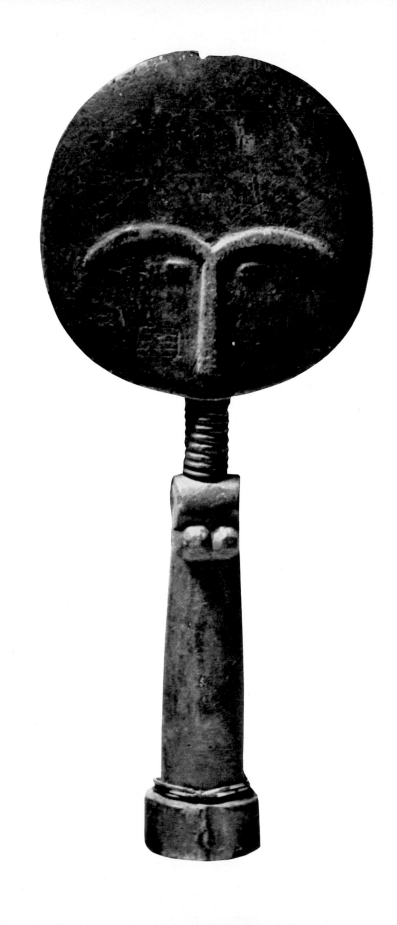

THIS small terracotta (27 cm high) also comes from the Ashanti of Ghana. It is a statue for the grave of a woman, probably a notable woman since she is seated on a stool. This type of stool, which is said in legend to have come down from heaven in about 1700 and to have landed out of the blue on the knees of the founder of the Ashanti kingdom, plays an important part in Ashanti life, with its religious and social, as well as functional, purposes. Its form and finish reflect the owner's social status during his lifetime; and after his death his soul can possess the seat during certain ceremonies. The stool-worship of the Ashanti takes the place of the ancestor-worship prevalent elsewhere in Africa, where the image is normally in human form. The serenity and majesty of the figure opposite are achieved in remarkably simple terms.

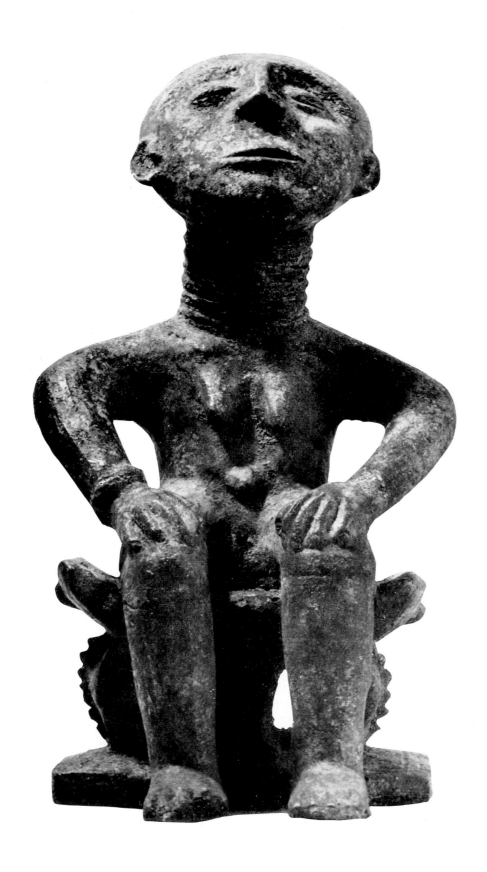

THE shaping of the face of this Ashanti grave image (height 20 cm) is similar to that of the *akua'ba*, although the figures have different functions. This is a terracotta, which suggests that it was made by a woman, since almost all African terracotta sculpture was done by women. It is not quite certain why this should be so, but it is likely to be related to the concept of the earth being female. The head is modelled like a flat disc, the eyes and the scarification on the cheeks being shaped like cowrie-shells, which would indicate a fertility function. The representation of the body is strange, with the sexual characteristics on the two upper mouldings and the feet only very summarily indicated on the lower one. The artist has captured the spirit of supernatural awe supremely well by creating a figure which seems no longer to belong to this world.

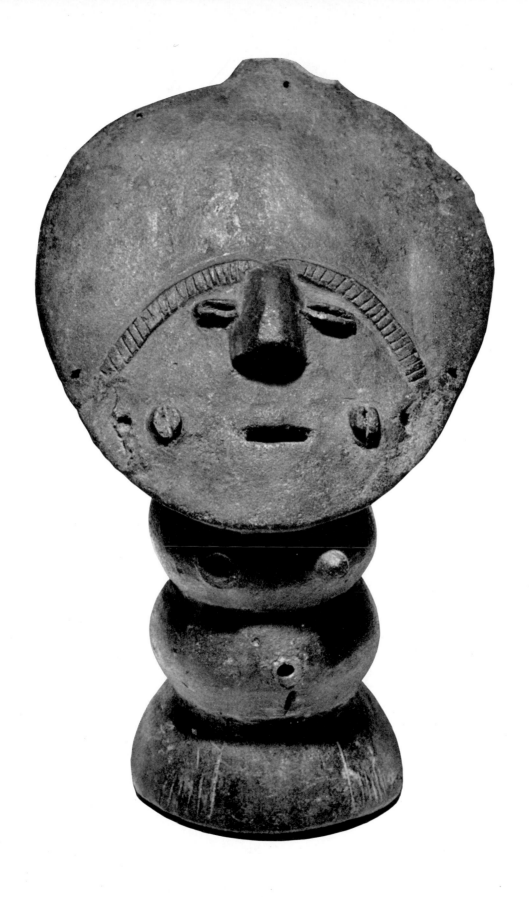

AN ANTELOPE mask (height 62 cm) of the Guro type. The artistically coloured antelope masks (war-masks) of this tribe are particularly well known although they tend to degenerate into clever pieces of craftsmanship, thereby losing some of their mystical quality. However, the mask opposite  has this quality in large measure. It is a black mask except for the space round the left eye, which has a red tint, and the mouth, where there are traces of red. And despite its clearly discernible antelope features (horns, mouth and the ovals round the eyes), it has that air of mystery which the sensitive eye will catch in many African animals. With its signs of wear on the inside, its many repairs on the sides and its lovely jet-black patina on the front of the horns, it is one of the finest examples of the Guro carvers' art. It may have been intended as a repository for the soul of the animal that was killed, made to prevent it from injuring the hunter.

The coloured masks mentioned above are known to be used in the Zamle secret society as war-masks, which seem very far removed from the gentleness of this mask.

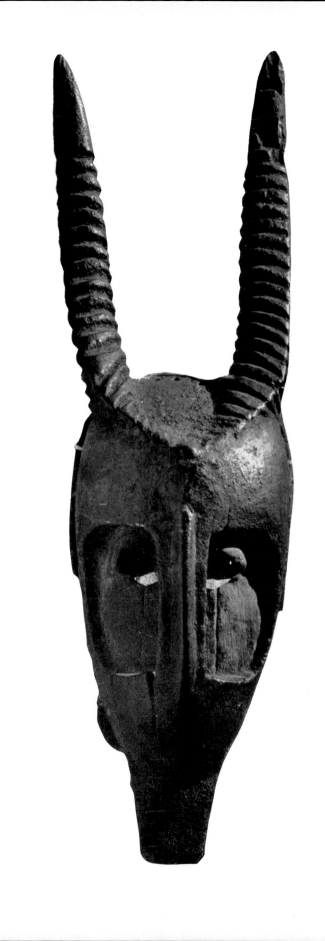

THIS is an ancestor figure of the Lobi tribe (height 40 cm), who produce, at the present time at least, only very 'wooden' figures of little power, sensitivity or artistic merit. The figure here, however, dates from an earlier time when the Lobi (who, at the beginning of this century, were not averse to cannibalism) had not yet come into contact with influences from the West. Or perhaps it happens to have been made by one of the few really gifted artists of more recent times. It is anyhow the embodiment of self-confident, superior power. Everything, the hair style, the eyes, the aristocratic eyebrows, the hooked nose and the protruding mouth, the sturdy neck and short arms—they all denote this one characteristic. We do not know what the figure was used for and little is known about Lobi mythology. Hence the simple description of 'ancestor figure'.

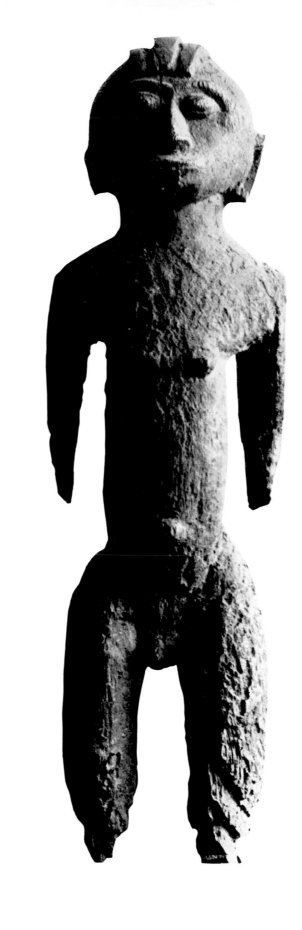

THE remarkable dog-faced baboon of the Baule tribe opposite is 55 cm high and represents the monkey-god Gbekre acting as judge over the spirits in the life hereafter. He is seated on a stool, a privilege reserved for dignitaries. The figure's forcefulness is centred entirely in the head, which indicates authority and demands respect. The remainder of the body, on the other hand, is carved in a rudimentary fashion so as not to distract one's attention. The hands hold a bowl for sacrifices, which has evidently been used on many occasions—in fact, the entire figure is encrusted with the residue of offerings (mostly chicken blood). The figure should be flanked by two human figures, smaller in size. Since they only serve as assistants, they are generally carved sketchily, and for this reason are usually missing in collections.

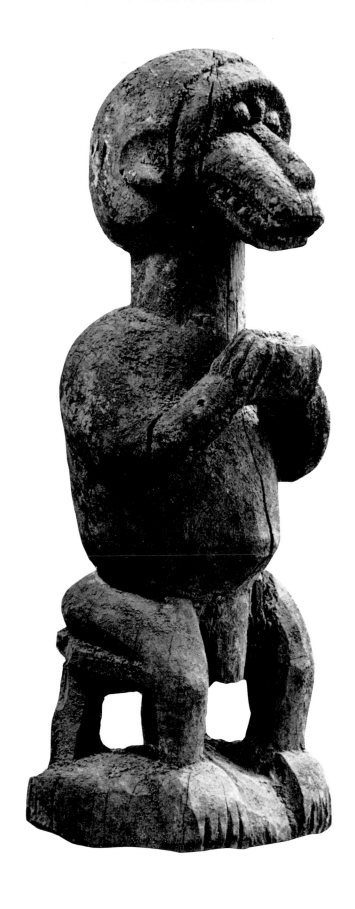

# SOURCES OF WORKS ILLUSTRATED

*pages* 25, 27, 29, 31,                    Author
33, 35, 37, 39,
41, 47, 53, 57,
61, 65, 67, 75,
85, 91, 93, 95,
99, 101, 103

45, 71, 73, 83, 87                         Afrika Museum, Berg en
                                           Dal (Holland)

49, 97                                     Galeric Khepri, Amsterdam

51                                         Miss V. Regnault, Laren
                                           (Holland)

59                                         R. Konings, Antwerp
                                           (Belgium)

63, 69                                     Prof. Th. van Baaren,
                                           Groningen (Holland)

79                                         Dr. J. van Haaren,
                                           Rosmalen (Holland)

81                                         Galerie Menist, Amsterdam

43, 55, 77, 89                             Not known

# BIBLIOGRAPHY

Adam, L., *Primitive Art*, 1953

*Arts connus et arts méconnus de l'Afrique noire*, Musée de l'Homme, Paris, 1966

Boas, F., *Primitive Art*, 1927; reprints, 1955, 1962

Calame, G., and Griaule, M., *Ethnologie et language*, 1965

Christensen, E. C., *Primitive Art*, 1955

Dieterlen, G., *Essai sur la réligion Bambara*, 1951

Einstein, C., 'Afrikanische Plastik', *Orbus Pictus*, vol. 7

Fagg, W., *The Webster Plass Collection*, British Museum, London, 1953

Fagg, W., and Elisofon, E., *The Sculpture of Africa*, 1958

Fagg, W., *Nigeria: 2000 Jahre Plastik*, 1961

Fagg, W., *Nigerian Images*, 1963

Fagg, W., and Plass, M. Webster, *African Sculpture*, 1964

Fagg, W., *Afrique, cent tribus, cent chefs d'oeuvre*, 1964

Fagg, W., *Tribes and Forms in African Art*, 1966

Gabus, J., *Art négre*, 1967

Goldwater, R., *Sculpture from Three African Tribes*, Museum of Primitive Art, New York, 1959

Goldwater, R., *Bambara Sculpture from the Western Sudan*, Museum of Primitive Art, New York, 1960

Goldwater, R., *Traditional Art of the African Nations*, Museum of Primitive Art, New York, 1961

Goldwater, R., *Senufo Sculpture from West Africa*, Museum of Primitive Art, New York, 1964

Griaule, M., *Masques Dogons*, 1938

Griaule, M., *Arts de l'Afrique noire*, 1947

Griaule, M., *Dieu d'eau*, 1948

Hermann, F., and Germann, P., *Beiträge zur Afrikanischen Kunst*, 1958

Himmelheber, H., *Negerkunst und Negerkünstler*, 1960

Holas, B., *Cultures matérielles de la côte d'ivoire*, 1960

Huet, M., and Fodéba, K., *Les hommes de la danse*, 1954
Kjersmeier, C., *Centres de style de la sculpture nègre africaine*, 1935
Krieger, K., *Westafrikanische Plastik*, Museum für Völkerkunde, Berlin, 1965
Langlois, P., *Tribus Dogons*, 1954
Laude, J., *Les arts de l'Afrique noire*, 1966
Lavachery, H., *Statuaire de l'Afrique noire*, 1954
Leiris, M., and Delange, J., *Afrique noire*, 1967; trans., *African Art*, 1968
Lem, F. H., *Sudanese Sculpture*, 1949
Leuzinger, E., *Afrika* (Kunst der Wereld), 1959; trans., *Africa: Arts of Negro Peoples*, 1960
Leuzinger, E., *Afrikanischen Skulpturen*, 1969
Meauzé, P., *L'art nègre*, 1967; trans., *African Art*, 1968
Münsterberger, P., *Primitive Kunst*, 1955
Olbrechts, F., *Les arts plastiques du Congo Belge*, 1959
Palau Marti, M., *Les Dogon*, 1957
Paulme, D., *African Sculpture*, 1962
Plass, M. Webster, *African Tribal Sculpture*, 1956
Plass, M. Webster, *African Miniatures: The Goldweights of the Ashanti*, 1967
*Présence Africaine*, 'L'Art Nègre', nos. 10 and 11, 1951
Rachewiltz, B. de, *Black Eros*, 1963
Radin, P., and Sweeney, J. J., *African Folktales and Sculpture*, 1952
Rasmussen R., *Art Nègre*, 1951
Ratton, Ch., *Masques africains*, 1961
Robbins, W., *African Art in American Collections*, 1966
Roy, C., *Kunst der Naturvölker*, 1957
Saaler, M. E., *Arts of West Africa*, 1965
Schmalenbach, N., *Die Kunst Afrikas*, 1953; trans., *African Art*, 1953
Sierksma, F., *De roof van het vrouwengeheim*, 1962
Segy, L., *African Sculpture Speaks*, 1961
Sweeney, J. J., *African Negro Art*, 1935
von Sydow, E., *Afrikanische Plastik*, 1954
Teeuws, Th., *De Luba mens*, 1962
Tempels, P., *Bantu philosofie* 1956; trans., *Bantu Philosophy*, 1956
Trowell, M., *Classical African Sculpture*, 1954
Underwood, L., *Bronzes of West Africa.* 1949
Underwood, L., *Masks of West Africa*, 1952; new ed. 1964
Underwood, L., *Figures in Wood of West Africa*, 1951; new ed. 1964
Vandenhoute, P. J. L., *Classification stylistique des masques Dan et Guéré*, 1948
Vatter, E., *Religiöse Plastik der Naturvölker*, 1926
Wingert, P., *The Sculpture of Negro Africa*, 1950

# MUSEUMS WITH COLLECTIONS
# OF AFRICAN ART

*Belgium*

Antwerp: Ethnografisch Museum
Brussels: Koninlijke Musea voor Kunst en Geschiedenis
Diest (Brabant): Kongo-Ucle Museum
Renipont-Lasne (Brabant): Museum Ribauri
Tervuren: Koninklijke Museum voor Midden Afrika

*Canada*

Toronto: Royal Ontario Museum of Archaeology
Vancouver: Vancouver City Museum

*Denmark*

Aabenraa: Aabenraa Museet
Copenhagen: National Museet
Hjørring: Vendsyssels Historiske Museum

*France*

Bordeaux: Musée Ethnographique de la Faculté de Médecine
Cannes: Musée de la Castre
Carcassonne: Musée des Beaux Arts
Cherbourg: Musée d'Histoire naturelle, d'Ethnographie et de Préhistoire
Grenoble: Musée d'Histoire naturelle et d'Ethnologie
Honfleur: Musée Normand d'Ethnographie
La Rochelle: Musée d'Orbigny-Bernon
Lyons: (i) Musée des Missions Africaines
    (ii) Musée Guimet
Niort: Musée des Beaux Arts
Paris: (i) Musée de l'Homme
    (ii) Musée des Arts Africaine et Océaniens

## Germany (West)

Bad Dreiburg (Westfalen): Völkerkundliches Missionsmuseum
Berlin: Museum für Völkerkunde
Bremen: Übersee Museum
Brunswick: Städtisches Museum
Cologne: Rautenstrauch-Joest Museum
Frankfurt-am-Main: Städtisches Museum für Völkerkunde
Freiburg-in-Breisgau: Museum für Völkerkunde
Göttingen: Sammlungen des Instituts für Völkerkunde
Hamburg: (i) Hamburgisches Museum für Völkerkunde
  (ii) Museum für Kunst und Gewerbe
Hanover: Niedersächsisches Landesmuseum
Heidelberg: Völkerkundemuseum
Kiel: Museum für Völkerkunde
Lübeck: Völkerkunde Sammlung
Mannheim: Völkerkundliche Sammlungen
Marburg (Lahn): Religionskundliche Sammlungen der Universität
Munich: Staatliches Museum für Völkerkunde
Offenbach (Main): Deutsches Ledermuseum
Osnabrück: Städtisches Museum
Stuttgart: (i) Museum für Völkerkünde
  (ii) Linden Museum

## Great Britain

Birchington (Kent): Powell Cotton Museum
Brighton: Art Gallery and Museum
Cambridge: University Museum of Archaeology and Ethnology
Edinburgh: Royal Scottish Museum
Glasgow: (i) Glasgow Art Gallery and Museum
  (ii) Hunterian Museum of the University of Glasgow
Leeds: Leeds City Museum
London: (i) Commonwealth Institute
  (ii) Horniman Museum
  (iii) The British Museum
New Barnet (Herts): Abbey Art Centre and Museum
Oxford: Pitt Rivers Museum

<p align="center">*Holland*</p>

Amsterdam: Tropenmuseum
Berg en Dal: Afrika Museum
Breda: Rijksmuseum voor Volkenkunde
Delft: Etnografisch Museum
The Hague: Muscum voor het Onderwijs
Leiden: Rijksmuseum voor Volkenkunde
Otterlo: Rijksmuseum Kröller-Muller
Rotterdam: Museum voor Land- en Volkenkunde
's-Heerenberg: Afrika Museum
Tilburg: Nederlands Volkenkundig Missiemuseum

<p align="center">*Italy*</p>

Genoa: Museo Civico Etnografico
Rome: (i) Museo Missionario Etnologico Lateranense
  (ii) Museo Preistorico Etnografico Luigi Pigorini
  (iii) (Vatican) Musei Lateranensi

<p align="center">*Norway*</p>

Oslo: Universitetets Etnografiske Museum

<p align="center">*Spain*</p>

Barcelona: Museo Etnologico
Madrid: (i) Museo Etnologico
  (ii) Museo de Historia Primitiva

<p align="center">*Sweden*</p>

Göteborg: Etnografiska Museett
Jönköping: Länsmuseet
Stockholm: Statens Etnografiska Museum

<p align="center">*Switzerland*</p>

Basle: (i) Museum der Basler Mission
  (ii) Museum für Völkerkunde
Berne: Bernisches Historische Museum
Boudry (Neuchâtel): Musée de l'Areuse
Burgdorf (Berne): Sammlung für Völkerkunde
Fribourg: Musée africain
Geneva: Musée et institut d'Ethnographie
La Chaux-de-Fonds: Musée des Beaux Arts at Musée d'Ethnographie

<p align="center">III</p>

Neuchâtel: Musée d'Ethnographie
Payerne: Musée Payerne
Sainte-Croix: Musée Sainte-Croix
St. Gallen: Neues Museum
Solothurn: Museum der Stadt Solothurn
Winterthur: Museum der Stadt
Zug: Afrika Museum
Zürich: (i) Museum Rietberg
  (ii) Sammlung für Völkerkunde der Universität Zürich

## U.S.A.

Baltimore (Md.): Museum of Art
Berkeley (Calif.): Robert H. Lowrie Museum of Anthropology
Birmingham (Ala.): Museum of Art
Bloomington (Ind.): Indiana University, Department of Fine Art
Buffalo (N.Y.): Museum of Science
Burlington (Vt.): University of Vermont
Cambridge (Mass.): Peabody Museum of Ethnology
Chicago (Ill.): (i) Art Institute
  (ii) Natural History Museum
Cleveland (Ohio): Museum of Art
Denver (Colo.): Art Museum
Detroit (Mich.): Institute of Art
Hampton (Va.): Hampton Institute
Hartford (Conn.): Wadsworth Atheneum
Los Angeles (Calif.): University of California at Los Angeles Ethnic Collections
New Haven (Conn.): Yale University Art Gallery
New York City: (i) American Museum of Natural History
  (ii) Brooklyn Museum
  (iii) Museum of Primitive Art
Philadelphia (Penn.): (i) University Museum
  (ii) Museum of Art
Provincetown (Mass.): Chrysler Art Museum
Salem (Mass.): Peabody Museum
Santa Barbara (Calif.): Museum of Art
Scranton (Penn.): Everhart Museum
Washington (D.C.): (i) Howard University
  (ii) Museum of African Art
  (iii) Smithsonian Institution

# INDEX

*akua'ba*, 92, 96
Amma, 24, 28, 40
ancestors, 12, 78, 94
ancestor images, 14, 18, 28, 36, 40, 44, 80, 82, 100
animal figures and masks, 15. *See also under separate animals' names*
animism, 12
antelope, 56, 58, 62, 78, 98
Ashanti, 92, 94, 96

baboon, 102
Baga, 13, 76
Bakongo, 15
Bakuba, 13, 15
Baluba, 13
Bambara, 13, 21, 46, 52–58, 62, 78, 86
Bantu, 12
Baule, 13, 15, 102
Bayaka, 13
Bini, 13–15
bird figures and masks, 42, 44, 64, 68, 72, 90
blood, libations of, 17, 42, 102
Bobo, 13, 64
brass, 17, 92
bronze, 14, 17, 92
butter, rubbed into images, 17

cam-wood, 50
Cameroon, 48
chameleon, 90
*chi wara* head-dress, 56, 58, 62, 86
colouring of images, 21, 26, 50, 64, 68, 98
cowrie-shells, 52, 54, 62, 82, 96
cream, libations of, 38
crocodile, 44, 90

*daleu*, 86
Dan, 13, 68, 70, 72, 74
dances, 14, 44

dead, cult of, 14, 15, 26, 64, 80. *see also* grave-images
Derain, collection of primitives by, 18
devils' heads, 48
Dogon, 13, 17, 24–36, 40, 42, 44, 78, 80
drum, 48

ebony, 17

fakes, 20–21
Faro, 56
fertility images, 15, 28, 54, 80, 92, 96
fertility rites, 15, 52–56, 62, 64, 86, 90. *see also* rain
fetishes, 15
frog, 90

Gaboon, 48
Gbekre, 102
gold, 92
granary doors, 28
grave-images, 94, 96
Griaule, M., 42
Guro, 13, 98

hare, 42
head-dresses, 56, 58, 62, 84, 86
hermaphrodite, 36
hornbill, 90
horns, 52, 56, 58, 62
horse, 24, 88
hunting, 42, 64, 98
hyena, 42, 60

Ila-Orangun, 50
indigo, 21, 50
iron, 17

Kanaga-mask, 44
Katiéléo, 90

Kjersmeier collection, 54
Kola-nuts, 17, 68
Koré society, 60
Korhogo, 82, 90
Kurumba, 78
Kwonro head-dress, 84

libations, 16, 17, 21, 36
lizard, 90
Lo society, 80, 82, 84, 86
Lobi, 13, 100

Malinke, 54, 62
masks, 12–18, 26, 42–46, 52, 56–78, 82, 98
Massa cult, 80
*maternités*, 15, 30
Matisse, collection of primitives by, 18
medicine-man, 16, 88
milk, libations of, 17
millet, 28, 38
moon-symbol, 64
mud, rubbed into images, 17

nail effigies, 15
Nimba péfète, 76
Nommo, 24, 32, 38
N'Tomo society, 52, 60

oil, rubbed into images, 17, 50, 58
owl, 64

paint, 21, 68, 84
patina, 16–17, 20–21, 32–38, 42, 46, 56–60, 68–76, 90, 98
Picasso, collection of primitives by, 18
pole carvings, 80
Poro society, 66, 68, 70, 74
portrait-images, 15

rain, prayers for, 28, 32, 38, 60, 88
rats, damage by, 38
Reckitt's blue, 21
rhythm-pounder, 80

secret societies, 15, 44, 52, 60, 66, 68, 70, 74, 76, 80, 82, 84, 98
Senufo, 13, 21, 46, 80–90
Simo society, 76
Sinemataili, 82
spirits, 12, 52, 64, 78
staff, ritual, 86, 90
stilts, 74
stone, 17
stools, 94, 102

tattoos, 40, 74
Tellem, 24, 28, 30, 32, 34, 38, 78
Tempel, Father: *Bantu Philosophy*, 12
termites, damage by, 17, 58
terracotta, 94, 96
totem animals, 84, 90
tortoise, 90
tukula wood, 17
twins, 50

Vlaminck, collection of primitives by, 18

war-masks, 98
wax, rubbed into images, 58
weaving, 32
wood, kinds of, 17

Yoruba, 50

Zamle society, 98